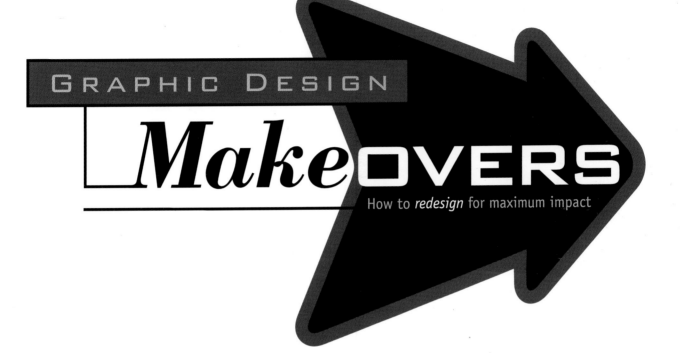

GRAPHIC DESIGN

Make OVERS

How to *redesign* for maximum impact

GRAPHIC DESIGN

Make OVERS

How to *redesign* for maximum impact

POPPY EVANS

NORTH LIGHT BOOKS

Cincinnati, Ohio
www.howdesign.com

Visit our Web site at www.howdesign.com for information on more
resources for graphic designers.

05 04 03 02 01 5 4 3 2 1

Library of Congress Cataloging-in-Publication Data
Evans, Poppy
 Graphic design makeovers : how to redesign for maximum
 impact / Poppy Evans.— 1st ed.
 p. cm.
 Includes indexes.
 ISBN 1-58180-029-0 (pbk. : alk. paper)
 1. Commercial art—United States—Handbooks, manuals, etc.
 2. Graphic arts—United States—Handbooks, manuals, etc. I. Title.

NC1000 .E9 2000
741.6—dc21 00-042367

Editor: Linda H. Hwang
Production coordinator: Kristen Heller
Designer: Chris Gliebe, Tin Box Studio, Inc.
Production artist: Joy Morrell

Dedication

This book is dedicated to my family: my parents, Bill and Letha Evans, who have always supported me in everything I've done; my brother Bill and his wife, Pat, who never let me forget my roots; and finally my son, Evan, who challenges me to be the best mom and person I can be.

Acknowledgments

I would like to thank Lynn Haller at North Light Books for coming up with the idea for this book, Linda Hwang for her initial input on editing this book, Kristen Heller for steering it through production and Chris Gliebe for his striking design and layout.

Most important of all, I would like to thank the designers who contributed the project case studies to this book. All of these individuals took time from their busy schedules to furnish me with information as well as art and photography. Many of them also went out of their way tracking down clients and seeking their approval to show the before versions of their redesigns.

To everyone who helped through their advice and ideas, my heartfelt thanks.

CONTENTS

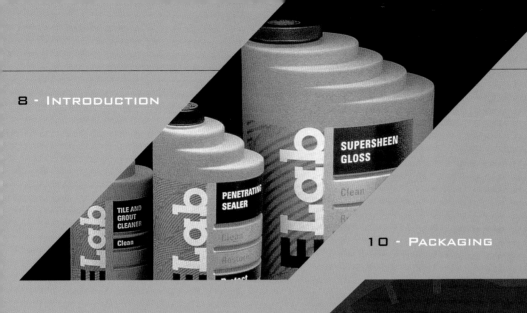

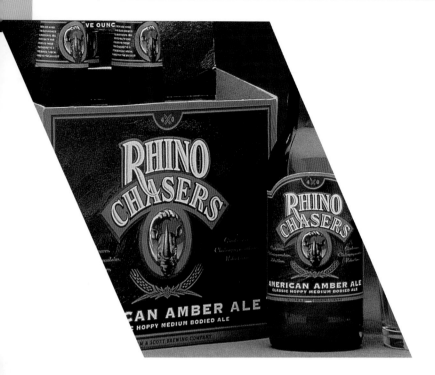

How often have you looked at a piece and thought, "I would have designed that differently." Or, on the flip side, you see another designer's version of a design you originated a few years back and wonder "Why did they change it?" You may have even revisited a piece you created a few years ago that a client wants you to redesign with a new twist.

If you've been there and done that, you're not unlike most designers. Makeovers of existing designs are as much a part of being a designer as starting from scratch with an entirely new idea.

As the writer behind *Publish* magazine's monthly "Makeover" column for over five years, I tried to understand and present the reasons, design strategies and production issues behind over fifty redesigns. Although I went into the column commitment naively thinking that I would be showing readers how "bad" design became "good" design, I quickly found out that redesigns happen for other reasons: A company gets bought out and the new owner wants a new image. An identity that looked great when it was designed fifteen years ago now looks terribly dated. A start-up business has grown to the point where it can afford a four-color budget and an image upgrade.

This book has been a similar experience. The sixty-five makeovers it contains cover a broad range of project types and redesign reasons. Like my experience with the "Makeover" column, I've found that the examples in this book represent changes in marketing strategy, budget allocation or client vision, but never situations where "bad" was made "good."

More important, these project case studies represent situations where client and designer have learned by example. I've found that with makeovers, what happens as a result of the first design influences whatever happens with the new design. The second time around affords the opportunity to improve on what existed before. Understanding what will improve the piece and being able to implement that are essential to success.

Consider the assortment of case studies in this book a chance to understand how "old" becomes "new," how problems are rectified and improvements are made, how good is made better—a quintessential opportunity to learn by example.

PACKAGING

Sparkling Water Gets a Refreshing New Look

Firm: Hornall Anderson Design Works, Inc.

Art director: Jack Anderson

Designers: Jana Nishi, Julia LaPine, Jill Bustamante, Heidi Favour, Leo Raymundo

Illustrator: Julia LaPine

Client: Talking Rain Beverage Company/beverage manufacturer

Problem: To be competitive, client wanted a more upscale, elegant look.

Talking Rain is a leading regional brand of natural noncarbonated water, sparkling waters and all-natural juices, teas and fruit-flavored beverages in the Pacific Northwest. The beverage manufacturer wanted to leverage its Sparkling Ice product—flavored carbonated water—against some new competition when it contacted Hornall Anderson Design Works, Inc. about a packaging redesign. "Clearly Canadian had come out with this thin bottle, and Talking Rain's bottle was short and stubby," says Jana Nishi, one of the designers on the project. "The client decided they wanted something more elegant."

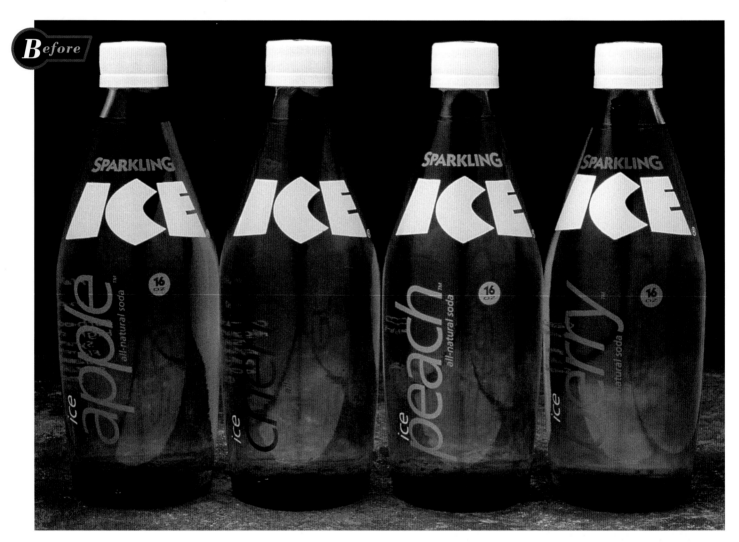

Because Sparkling Ice was being threatened by an onslaught from potential competitors, its packaging needed to be upgraded to a slimmer, more contemporary look.

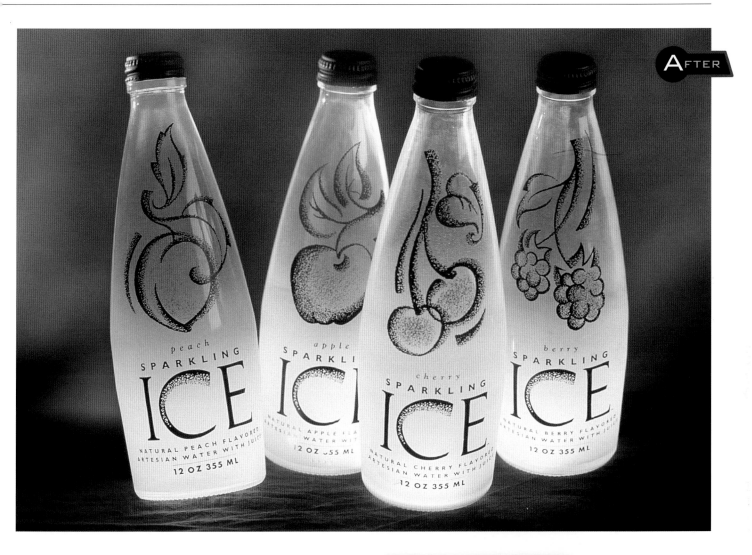

The designers first came up with a new bottle design which is thinner than Sparkling Ice's previous bottle. To give the bottles an icy look, they were treated with a baked-on enamel. "They look like they came right out of the refrigerator," says Nishi.

The Sparkling Ice logotype was redesigned to give *Ice* a frosty appearance—the designers embellished the *c* with a frosted look. Swirl-embellished, airy illustrations were developed for each of Sparkling Ice's five flavors and given the same frosty appearance as the *c* in *Ice*.

The result is a look that's much more refreshing than Sparkling Ice's previous bottle. The new look has been incredibly successful for the brand, resulting in a market that's expanded far beyond the Pacific Northwest. "We were able to reposition it and come up with a look for Ice that's in forty-six states now," says Hornall Anderson principal Jack Anderson.

(Top) The new bottles not only look more elegant, they have a permanently frosted appearance resulting from baked-on enamel. (Below) An alternative design that was not chosen.

Energetic Graphics and Appetite Appeal Improve Product Packaging

Firm: Libby Perszyk Kathman

Art director: Matt Baughan

Designers: Jamie Makstaller, John Kuchenmeister

Client: Morningstar Farms/manufacturer of meat-free products

Problem: Client wanted more upbeat package design.

Morningstar Farms had a more energetic and contemporary image in mind when the food manufacturer's executives contacted Libby Perszyk Kathman (LPK) about updating its current package design. However, Morningstar Farms had significant equity in its existing packaging, a green box that prominently featured an image of the prepared product.

"When people walk down the grocery aisle searching for their products, they actually look for a green package," explains Geoff Thomas, LPK's account executive on the Morningstar project, of the equity that existed in Morningstar Farms's green box. With this in mind, Thomas and the others on LPK's design team decided to work with the green background and preserve the overall look of Morningstar Farms's existing packaging. Their goal was to work within these parameters while enlivening and modernizing Morningstar Farms's image.

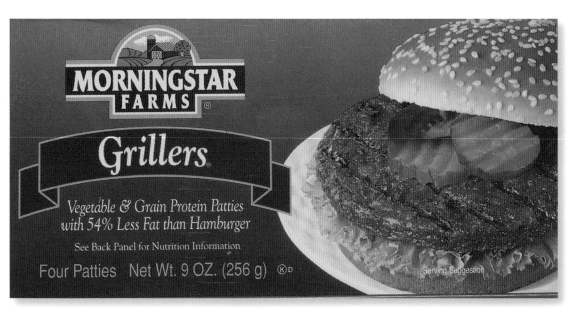

Morningstar Farms wanted to update its current package design, but consumers were accustomed to recognizing the company's products by their green boxes.

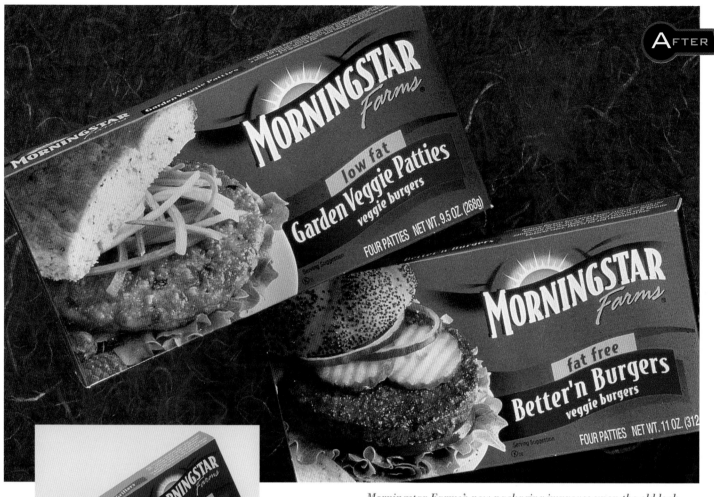

Morningstar Farms's new packaging improves upon the old look with an enlivened logo and graphics and a product shot with more appetite appeal.

The LPK design team started with the logo. "We added a little motion, a curvilinear shape," says Thomas of the typographic treatment the design team gave the Morningstar Farms name. The Morningstar name's custom typography was created from Bodega. *Farms* was hand-rendered by LPK design director Tim Smith.

From there, the designers added an image of a rising sun, the morning star. "You definitely draw an association with the morning, a fresh new day," says Thomas. The product name banner at the bottom of the package echoes the fluid movement of the logo. "It gives the package more energy," says Thomas. "What we wanted to drive home was fun,

energy and a more contemporary look." For a three-dimensional look, the banner is shaded with a gradient at the point where it connects with the product photo. Type within the banner is set in Bodega.

LPK had new product shots made for each of Morningstar Farms's twenty-four products. The new images enhance the packages' appetite appeal with a closer view of the prepared product.

New Design Moves Brand From Contractors to Consumers

Firm: Hornall Anderson Design Works, Inc.

Art director: Jack Anderson

Designers: Jack Anderson, Lisa Cerveny, Bruce Branson-Meyer, Alan Florsheim

Client: Custom Building Products/manufacturer of stone and tile restoration products

Problem: Package design needed more shelf presence for its move into the consumer marketplace.

Custom Building Products's executives were in the process of rethinking their branding and marketing strategy for the company's tile care and restoration products when they contacted Hornall Anderson Design Works, Inc. about a package redesign. The company wanted to move into the consumer market without alienating its contractor customer base. "We recommended that they develop a 'subbrand,'" says Lisa Cerveny, of Hornall Anderson Design Works, Inc. Together, Hornall Anderson's design team, a naming partner and their client came up with "Tile Lab," a more consumer-friendly name.

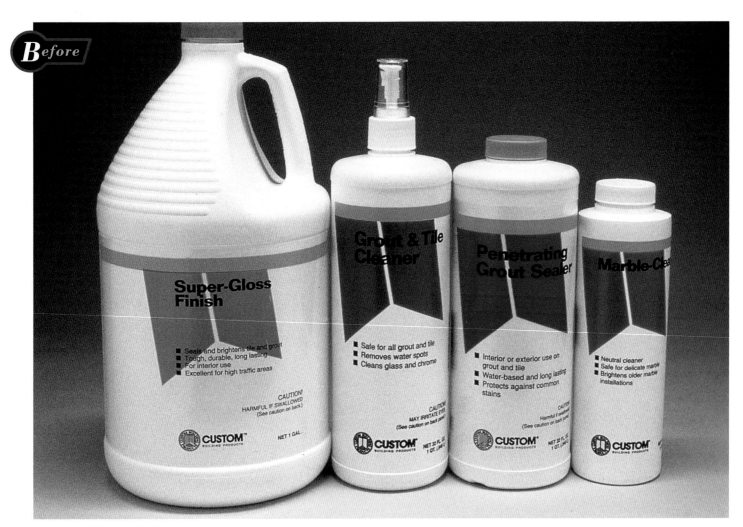

Custom Building Products's tile restoration product packaging had been directed at contractors. To make the move into the consumer realm, the packaging needed more shelf presence and consumer appeal.

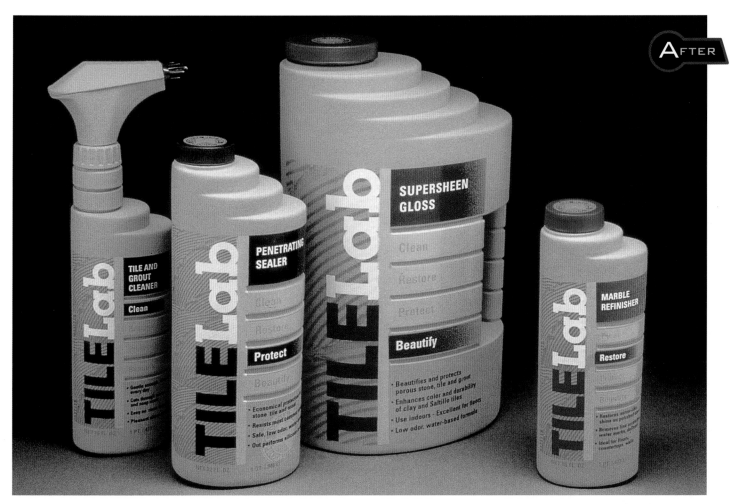

"We were first asked to use stock bottle shapes," says Cerveny. "As we began investigating design solutions, it became pretty clear that that there were strong consumer associations with shampoos and motor oil. We told them if they really wanted to set their product apart, they should consider a custom bottle." To emit a stronger brand identity and shelf presence, Hornall Anderson convinced its client to go with a proprietary bottle shape for each of Tile Lab's four products. "From there, we developed a stair-stepped, industrial feeling bottle," says Cerveny.

Hornall Anderson developed benefits-oriented copy that helps direct consumers to the product they need and, at the same time, inform them of what other product choices are available. "We thought this was a perfect opportunity to cross-sell as well as educate the consumer," says Cerveny.

A palette of red, green, blue and purple was developed to correspond with each of Tile Lab's four product categories: clean, restore, protect and beautify. To stand out on the shelf, these colors are used in combination with an attention-grabbing gold.

The Tile Lab logo Hornall Anderson designed merges a sans serif typeface with a slab serif.

A catchy name, uniquely shaped bottles, and bold colors and graphics did such a good job of catching consumers' attention, Tile Lab's sales increased 300 percent within the first six months after the new packaging was introduced.

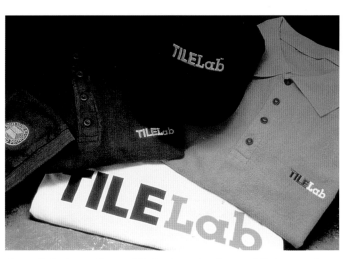

Hornall Anderson Design Works, Inc. also designed T-shirts and ball caps bearing the new Tile Lab identity.

Bolder Labels Helps Revitalize Brand

Firm: Shimokochi/Reeves

Art directors: Mamoru Shimokochi, Anne Reeves

Designer: Mamoru Shimokochi

Client: Leiner Health Products Inc.
manufacturer of personal care products

Problem: Product line's move into a competitive environment required a packaging design with more shelf impact.

When Bodycology moved its existing line of personal care products from in-store displays into a competitive retail environment, it called upon Shimokochi/Reeves to help restore the company's sagging sales. "Their products were originally merchandised in boutique display units," explains firm vice-president Anne Reeves. "That worked for the initial launch, but after that, Bodycology was taken 'in-line' on the retail shelves." Sold in drugstores and personal care specialty shops, Bodycology's product packaging didn't have enough shelf presence to compete effectively against other products.

To help Bodycology stand up against its competition, Shimokochi/Reeves wanted to strengthen the brand name and the impact of the product packaging. They discovered that one of the things that made Bodycology's products unique was their availability in thirty-three different fragrances. Although the source of each fragrance was illustrated on each product label, the illustrations' tiny size diminished their impact. "Consumers just didn't get it," says Reeves. To save their client the expense of having to reillustrate each fragrance, Shimokochi/Reeves increased the impact of Bodycology's existing illustrations and enlarged them to run at almost the full width of each bottle label. The highly visible illustrations register an immediate response from consumers who can now recognize their fragrance preferences from a distance.

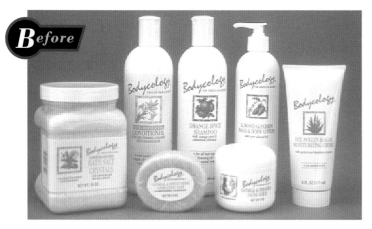

Bodycology's former packaging featured labels decorated with delicate illustrations and borders. Although pretty and feminine, they lacked shelf impact.

The Bodycology name was also given more impact. Reeves used a refined version of her own handwriting to create a bolder version of the script that was formerly used as the Bodycology logo. "It's a stronger, friendlier branding," says Reeves of the new Bodycology logo. The logo is further emphasized by its reversal within a dark green panel.

"Then we looked at the container," says Reeves. "Instead of opaque white, we selected a frosted container." The diffused look of the frosted containers adds a sense of quality to Bodycology's products and also helps consumers differentiate one fragrance from the next by its unique product color.

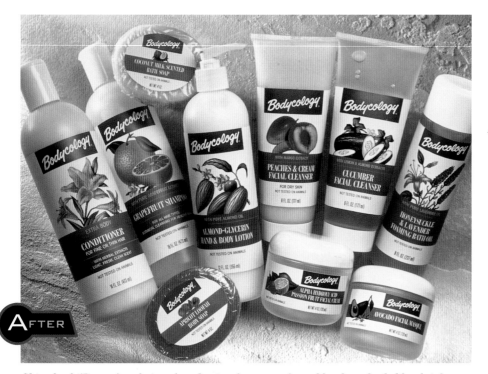

Shimokochi/Reeves's redesigned packaging features a frosted bottle and a bolder, brighter label design that lets consumers easily identify Bodycology's thirty-three fragrance varieties.

Burrito Sales Improve with Package Design's Fresh Look

Firm: Shimokochi/Reeves

Art directors: Mamoru Shimokochi, Anne Reeves

Designer: Mamoru Shimokochi

Client: Camino Real Foods, Inc./Mexican food manufacturer

Problem: Packaging's authentic Mexican look needed to be mainstreamed to appeal to a broader market segment.

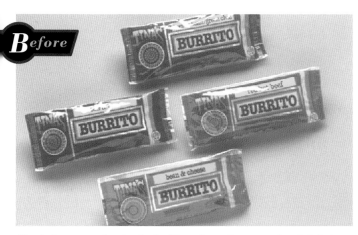

Tina's former packaging lacked broad market appeal and failed to establish a strong brand presence.

Tina's burritos sales were flat when Camino Real Foods president, Mits Arayama, contacted Shimokochi/Reeves about a packaging redesign for its burrito product line. "They wanted to revitalize their brand and have a look that would carry across the entire product line," says Shimokochi/Reeves vice-president Anne Reeves.

The designers at Shimokochi/Reeves noticed that Tina's existing packaging didn't clearly differentiate its burrito products from others in the supermarket freezer case. "It also looked too ethnic," says Reeves, referring to the packaging's sundial-like logo. "We decided to develop a stronger brand presence for Tina's that had broader consumer appeal."

Shimokochi/Reeves's new packaging design is a more contemporary look. For a custom touch, the new Tina's logo design features a serrated *I* that matches a serrated border at the top of the packaging's label panel. The black-and-white Tina's logo stands out in bold contrast to the bright colors of the burrito packaging.

For Tina's twelve flavor varieties, the designers retained the hot color palette dominated by orange, red and yellow with accents of purple, blue and green. Although the packaging colors are different for different flavors, the labels are graphically identical except for the flavor panel.

"It's consistent all the way across the product line, so it creates a bull's-eye effect in the freezer cabinet," says Reeves.

The new design has been so successful, it's had an immediate impact on Tina's sales. "The marketing director told us they increased their market share 27 percent within the year," says Reeves.

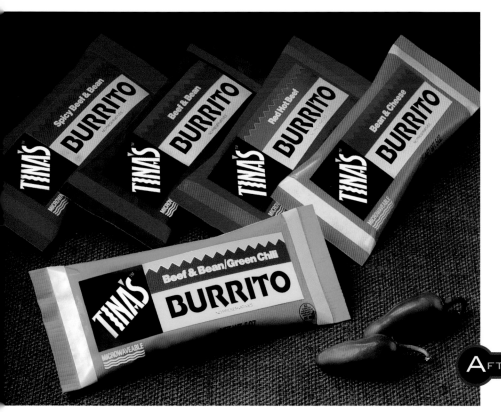

The new package design has a more contemporary, less ethnic look. Shimokochi/Reeves developed a coordinated packaging system to give the packaging for all Tina's burritos flavor varieties the same graphic look, while making it easy to differentiate one flavor from another.

Sunglasses Packaging Goes Natural

Firm: Hornall Anderson Design Works, Inc.

Art director: Jack Anderson

Designers: Jack Anderson, David Bates

Client: Smith Sport Optics/sport sunglasses manufacturer

Problem: Ski goggle manufacturer wanted a new image for its move into the sunglasses market.

Smith Sport Optics, a manufacturer of ski goggles, knew it was up against some stiff competition when it decided to move into the sunglasses market. Its existing sunglasses packaging, a fold-up box, carried the logo that appeared on its goggles. The logo may have worked successfully for ski goggles, but it failed to establish a strong graphic presence for the new sunglasses line. Hornall Anderson Design Works, Inc. was brought in to design a new packaging program as well as a new logo, based on the Smith name, which would work on sunglasses as well as the new package design.

"They realized they needed something more hip and modern," says Hornall Anderson principal Jack Anderson. Anderson and his design team sized up the competition and decided to develop a contemporary look for Smith that would stand out because it was different. Anderson says other competing brands had more fashion-oriented looks. "We had to do something that wasn't slick, glossy or a metal box."

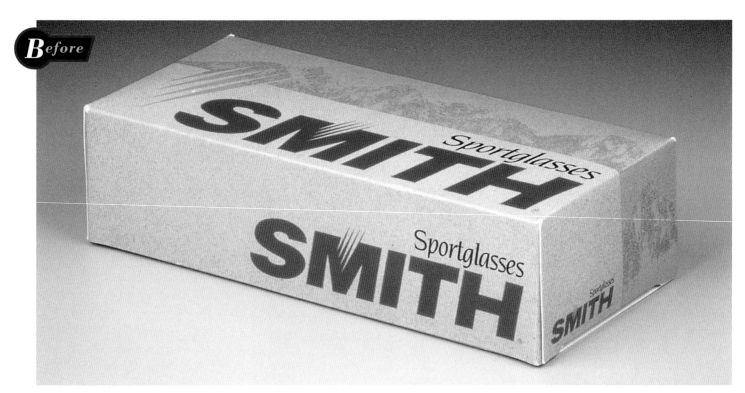

Smith's former sunglasses packaging borrowed the logotype from its ski goggles. Although the look worked for goggles, it lacked the shelf presence and youthful attitude necessary to appeal to the seventeen-to-forty age demographic.

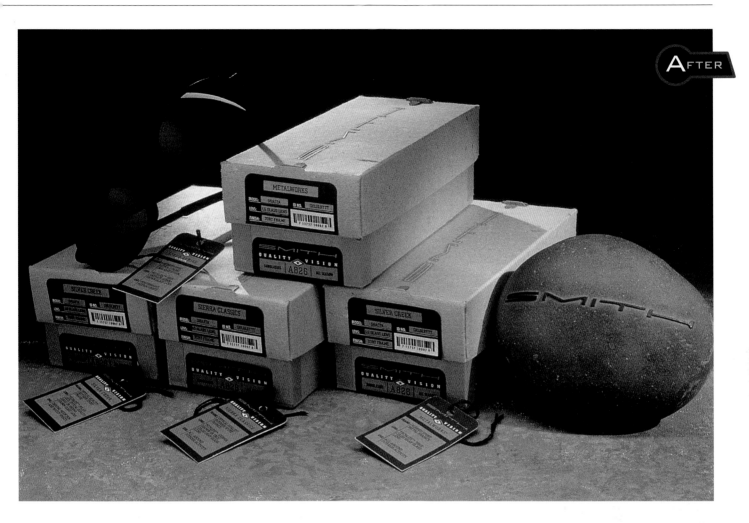
Instead, the designers developed a more raw-looking box made from chipboard with taped corners. Even the old-fashioned metal fasteners, which are used to secure the box lids to the box bottoms, are exposed for an industrial, warehouse look. The packaging's natural materials present an honest, no-nonsense image that appeals to Smith's seventeen-to-forty demographic of sports-loving individuals. It also reflects the sensibility of Sun Valley, where Smith's headquarters is located.

The new Smith logo, elegantly elongated to fit neatly on the sunglasses temple, is embossed with a tint-leaf enhancer on the box lid. A color-coded sticker program separates one sunglasses style from the next.

The new packaging's natural recycled materials are a reflection of Smith's Sun Valley headquarters. Its earthy look stands out against Smith's slick competition.

Sophisticated Imagery Speaks to Executive Set

Firm: Iridium Marketing & Design

Art director: Jean-Luc Denat

Designers: Etienne Bessette, Jean-Luc Denat

Photographer: Headlight Innovative Imagery

Client: Cognos/business intelligence software manufacturer

Problem: Client needed to target a higher level of customers' management.

Cognos, a business intelligence software manufacturer, wanted to reach the corporate decision makers at Fortune 500 companies. However, the computer-created special effects on its existing packaging appealed more to technical staff than to those who make the decision to purchase enterprise software. The updated packaging became part of an overall rebranding campaign to market Cognos products worldwide to a higher level of management.

Although Cognos's software products aren't sold in a retail environment where they would compete with other products on a shelf, Iridium felt a less high-tech look would help set Cognos apart from its competition. "We wanted to do something different," says Iridium art director Jean-Luc Denat. Denat and his design team decided to use abstract conceptual representations of what Cognos's software can do for its users. "We strove to create packages that invite you to think. We wanted to stimulate the viewer intellectually about the contents of the box," he explains.

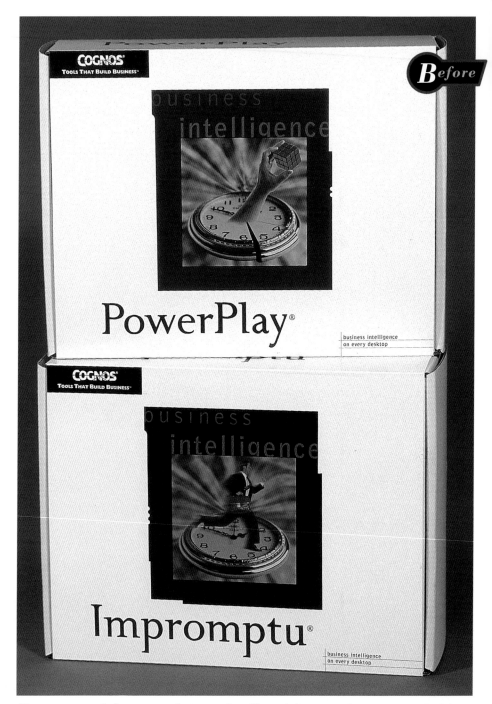

The computerized photo manipulation used on Cognos's former packaging is typical of the special effects frequently used on high-tech products. Cognos felt the look was more likely to appeal to users of the company's software products than to the executives who would be purchasing them.

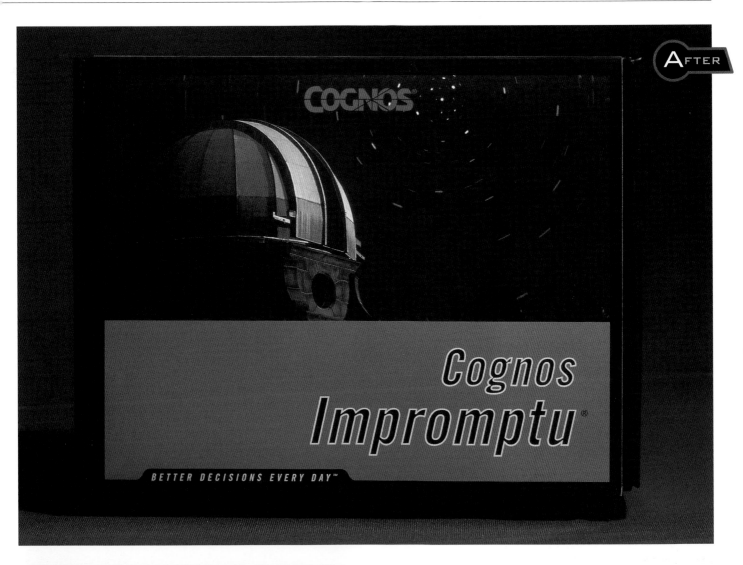

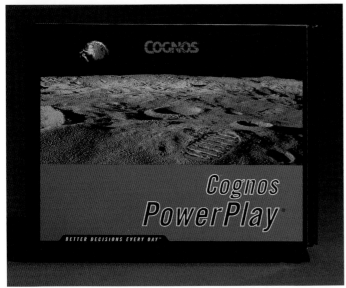

Neutral colors and traditional-looking photography convey a more sophisticated image. Cognos's new slogan, "Better decisions every day," reinforces the problem-solving features of the company's software products.

The designers came up with intriguing imagery to express this concept by creating image composites on the computer. For the Cognos Impromptu packaging, an observatory is combined with stars, set in motion with Adobe Photoshop's twirl filter. The Cognos PowerPlay packaging shows an astronaut's footprint on the moon, combined with a view of Earth from space. Although the images were created on the computer, they have the look of traditional photography. Iridium added richness to the images by converting them to duotones of black and champagne metallic.

The shimmery metallics coordinate with the metallic inks used on Cognos's promotional literature. Iridium's graphic treatment of Cognos's slogan, "Better decisions every day," is also consistent with its appearance on other materials, further unifying Cognos's visual branding.

Need to Reprint Prompts a Face-Lift

Firm: Hornall Anderson Design Works, Inc.

Art director: John Hornall

Designers: Jana Nishi, Debra McCloskey, Mary Chin Hutchinson

Client: Darigold/farmers' co-op

Problem: Packaging needed a stronger shelf presence.

Darigold, a local farmers' co-op selling dairy goods in the Pacific Northwest, needed to reprint its packaging to include nutritional content for each of its products. However, the dairy's executives felt that the time was ripe for a total packaging redesign. They contacted Seattle-based Hornall Anderson Design Works, Inc. looking for packaging redesign for all of its products and a strategy that would help strengthen Darigold's brand recognition.

"They originally came to us wanting a new logo," says Hornall Anderson's Jana Nishi. However, focus group research determined that consumers had warm feelings towards the existing logo: the Darigold name within a daisy-shaped "burst." Darigold's recognition problem stemmed from inconsistent treatment of the logo and its colors, as well as a lack of consistency and distinctive look in the overall graphic treatment of its packaging.

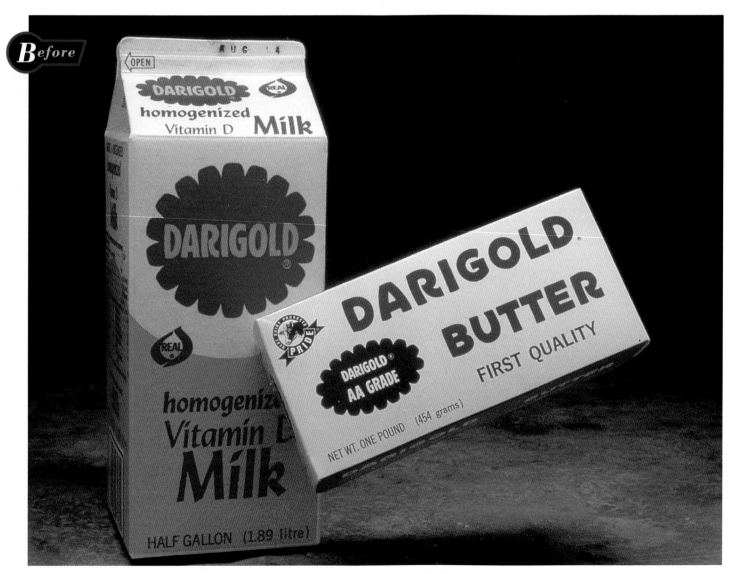

Darigold's former packaging looked dated and failed to establish a strong brand presence through consistent color and logo treatment.

The new packaging exudes country charm and displays a more consistent graphic treatment of the logo and other graphic elements.

"We made it more consistent," says Nishi of the decision to always feature the logo as a red and yellow elliptical daisy. From there, the design team incorporated the logo into a packaging system that created a more unified and consumer-friendly image. "It was important to show that the product was from a good place—the country," says Nishi regarding the pastoral illustration that was added to Darigold's new packaging. The depiction of cows grazing in front of a barn also includes a mountain in the background—a nod towards the area's Cascade Mountains. "They're proud of where they're from and they wanted that to be known," says Nishi. The checkerboard pattern was added to further instill a sense of country charm and provide an opportunity for color coding Darigold's various products.

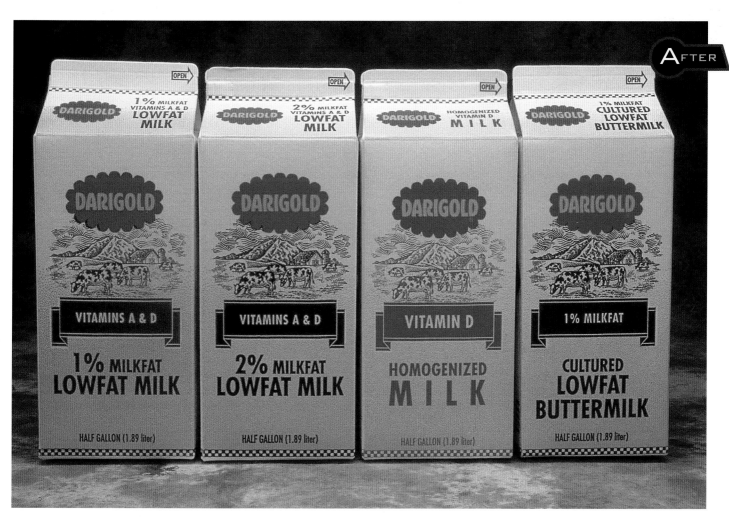

The banner that carries product names and varieties helps to strengthen the Darigold brand and help differentiate, by color code, one type of product from another.

Global Marketing Generates New Identity

Firm: Libby Perszyk Kathman

Creative director: Howard McIlvain

Designer: Rick Barrach

Client: The Valvoline Company/motor oil manufacturer

Problem: Product packaging needed to project a consistent image globally.

Inconsistent brand representation in different regions of the world prompted Valvoline to develop a new packaging concept that could be marketed all over the globe. "Depending on which country you were in, Valvoline motor oil was sold in plastic bottles of all types of colors, shapes and sizes," says James J. O'Brien, president of The Valvoline Company. "The only common denominator in our worldwide packaging was the familiar 'V' logo, and even that wasn't presented consistently."

Partnering with Libby Perszyk Kathman (LPK), Valvoline redesigned all of the elements in Valvoline's package design with globalization in mind. "We did an extensive predesign analysis, on a global basis, to get a sense of what color bottles were being used in other countries and what they meant to consumers," explains LPK's Claudia Gladstone, account executive for the Valvoline redesign. The LPK design team discovered that colors mean different things in different parts of the globe. "Black is associated with 'generic' or 'less expensive' in Europe," says Gladstone. Gold is universally identified with a premium product.

Based on their research, LPK came up with color recommendations for each of Valvoline's motor oil product categories. Its All-Climate core product retains its white bottle. SynPower, its premium line, is packaged in a blue bottle. Durablend, Valvoline's superpremium product, is packaged in a gold bottle.

LPK's project team also recommended a new bottle design. "We tried to make it look even more proprietary," says Gladstone of the new bottle's angular lines. The designers were faced with the need to come up with a design that could be manufactured at Valvoline plants all over the world. "It also provides a functional aspect," says Gladstone of the new bottle's more grippable design. "It's also a very powerful image for Valvoline. When you look at the shelf and compare it to other motor oils, it's a very strong, angular shape and it gets your attention."

To be sure the new design standards, including a standardized label design, were enforced in all of Valvoline's global marketing regions, LPK's project team worked with Valvoline's internal design department in the development of a graphic standards manual.

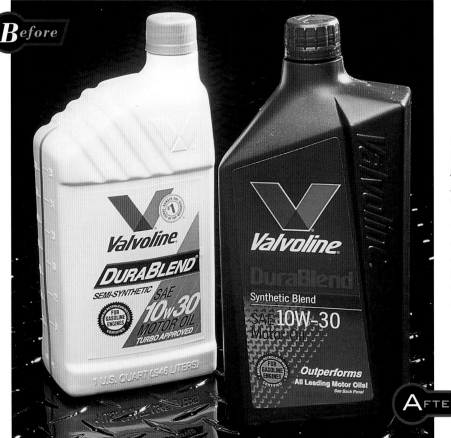

The inconsistent interpretation of the Valvoline brand by different marketing locations around the globe prompted Valvoline to come up with a new packaging system that the company could implement effectively on a worldwide basis.

Valvoline's new package design involved intensive research to determine what colors and bottle shapes would have consistent global meaning. Standards for the Valvoline bottle labels were also developed to ensure a consistent representation across a variety of regional manufacturing venues.

Headlight Packaging Gets a More Rugged Look

Firm: Hornall Anderson Design Works, Inc.

Art director: John Hornall

Designers: David Bates, Mike Calkins

Client: Warn Industries/fog beam lights manufacturer

Problem: Former packaging didn't stand up against competitors.

Former packaging for Warn's all-terrain vehicle fog beams had a slick look, similar to that of its competitors. As a result, the product failed to stand out from its competition or speak effectively to outdoors-oriented consumers.

When Warn Industries executives approached Hornall Anderson Design Works, Inc. about a redesign of Warn's all-terrain vehicle headlights packaging, they wanted a design that would appeal to a rugged, outdoors-oriented consumer. Warn's existing packaging design, with its metallic-look type and graphics, gave the packaging a slick, glitzy look. Principal John Hornall says the bright colors and slick image were typical of Warn's competitors. "Rather than go head-to-head on the colors, we created a design that spoke to the nature of the product and the kind of use it would get," says Hornall.

Warn executives had come up with a more consumer-friendly name for its product—"fog beam"—as opposed to the model number that formerly appeared on the package. They also wanted the product, consisting of one large and one small light, to be visible through the package. To play up the graphic nature of the large light, Hornall Anderson's designers incorporated a die cut into the new design to expose it. Three small holes provide visibility of the smaller light.

The box's graphics are an abstraction of the product's shape. Using product blueprints as a graphic element, Hornall Anderson designers created shapes in earth tones that echo the lines of the blueprint drawings.

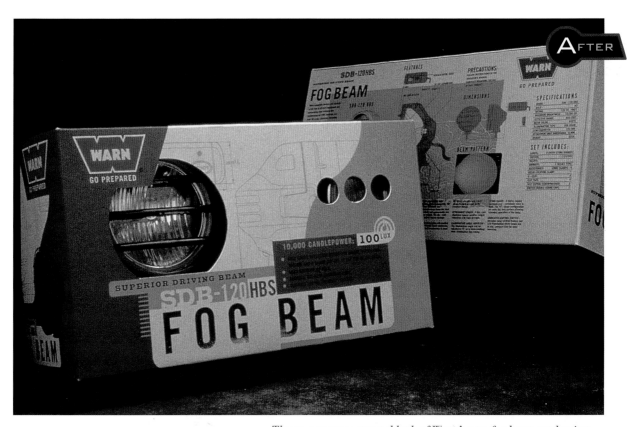

The no-nonsense, rugged look of Warn's new fog beam packaging helps the product stand out against the brightly colored boxes of its competitors.

Tool Innovator's New Packaging Stands Up to Imitators

Firm: Hornall Anderson Design Works, Inc.

Art director: Jack Anderson

Designers: Jack Anderson, Lisa Cerveny, David Bates, Alan Florsheim

Client: Leatherman Tool Group/tool manufacturer

Problem: Client needed to stand out against imitators threatening their market share.

As originator of the "go-anywhere, do-anything tool," Leatherman Tool Group was in a good position to reap rewards from the popularity of its innovative and useful products. However, the toolmaker's market share was being threatened by competitors who were marketing knockoffs or other tools that were similar to its products. When Leatherman executives met with Hornall Anderson Design Works, Inc., they wanted to strengthen Leatherman's brand identity and positioning in the marketplace in order to maintain a leadership position. "They wanted to upgrade the look of their packaging to make it more attractive to consumers," says Hornall Anderson designer Lisa Cerveny.

After analyzing Leatherman's competition, Hornall Anderson's design team determined that a graphic palette including consistent typography, consistent treatment of the Leatherman name and use of the same colors would best reinforce the Leatherman brand image. A natural look would help to strengthen Leatherman's appeal for consumers who frequently use the products when they are engaged in outdoor activities. To convey a "sportsman" look, images of sand dunes and waterfalls were also incorporated into the packaging's background graphics.

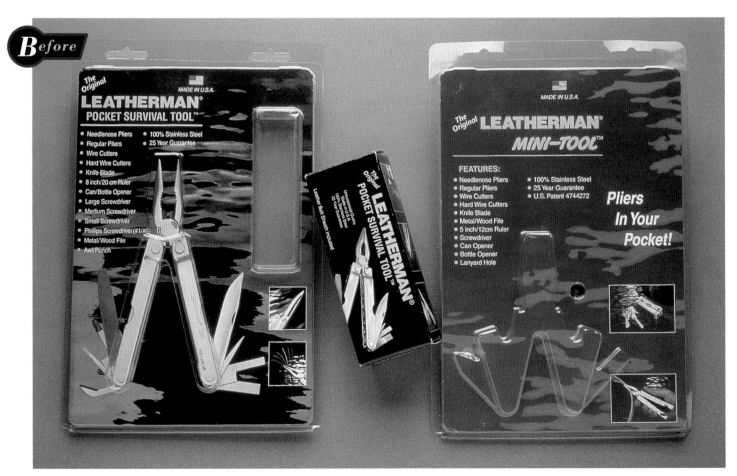

Leatherman's previous packaging was so nondescript it didn't position the brand as a leader in its product category.

The Hornall Anderson design team came up with a color palette that plays basic primary and secondary colors against a natural kraft background. The look was adapted for boxes that could be displayed on counters and shelves, as well as clamshell packaging that could be hung on hooks. "Larger stores will merchandise the tools on hanging hooks to conserve space. Specialty stores will merchandise them in boxes," explains Cerveny.

Leatherman wanted to maintain the look of its existing logo, so Hornall Anderson's designers kept Leatherman's sans serif logotype, but to strengthen the name, they switched to a bolder, more condensed typeface.

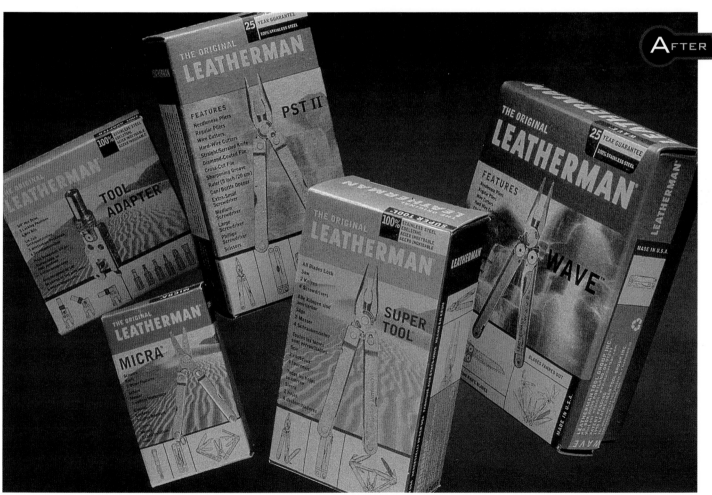

The new packaging design conveys more of a quality look and is likely to appeal to its target audience of outdoor sportsmen. "If you look at the competitors, Leatherman stands out," says Lisa Cerveny, principal designer.

Beer Packaging Targets Youthful Market

Firm: Hornall Anderson Design Works, Inc.

Art director: Jack Anderson

Designer: Larry Anderson

Illustrator: Mark Summers

Typography: Solotype

Client: Rhino Chasers/microbrewery

Problem: Client needed a stronger image targeted to a youthful market.

Rhino Chasers microbrewery started when a group of individuals in a baseball club decided to brew their own beer. Although the beer's name is derived from die-hard surfers of forty- and fifty-foot waves called "rhinos," Rhino Chasers was still using a rhinoceros and a baseball motif on its packaging when the company's leaders contacted Hornall Anderson Design Works, Inc. about a packaging redesign.

The term *rhino chasers* refers to individuals who challenge extreme conditions to achieve their personal best. "They're edgy, no-fear individuals," says Hornall Anderson's Larry Anderson, "but their packaging didn't exude that." To appeal to a youthful market, Larry Anderson and his fellow designers wanted to convey this free-spirited, "no-fear" attitude in Rhino's logo, so they chose to depict a rhino charging out from within the curl of a wave. "We spent a great deal of time trying to bring out a certain character in the rhino face itself," says Anderson. After looking at the work of several freelance illustrators, Mark Summers was chosen to create the new Rhino Chasers logo.

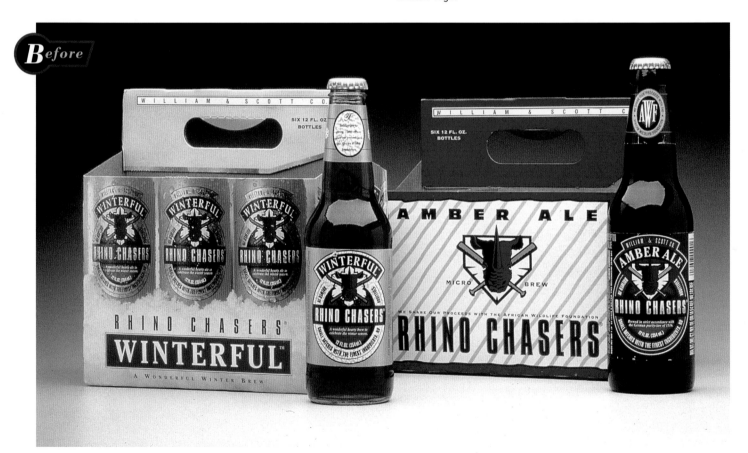

The generic quality of Rhino Chasers' former packaging did little to promote the beer to the athletic, youthful market targeted by the microbrewery.

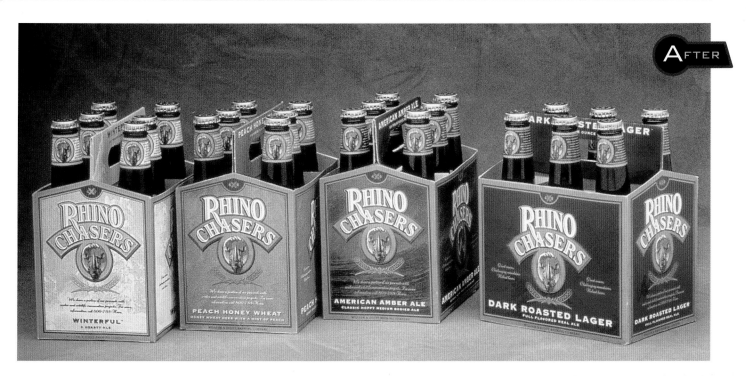

The rhino is positioned within a medallion bearing the Rhino Chasers name set in a custom typographic configuration created by Solotype. In their selection of an antique typeface and an illustration style resembling a linocut, Hornall Anderson was striving for a look that evokes a sense of craftsmanship and pride in beer making.

The medallion appears on Rhino Chasers labels and cartons against a background of subtle outdoor scenes. Each of Rhino Chasers four varieties of beer features a different scene against a different-colored backdrop. For instance, the dark lager is packaged in a predominantly rust-colored backdrop of a canyon, while the winter beer's packaging is a silver and white snow scene.

The packaging redesign was part of a major rebranding effort for Rhino Chasers that yielded a 200 percent increase in the microbrewery's sales.

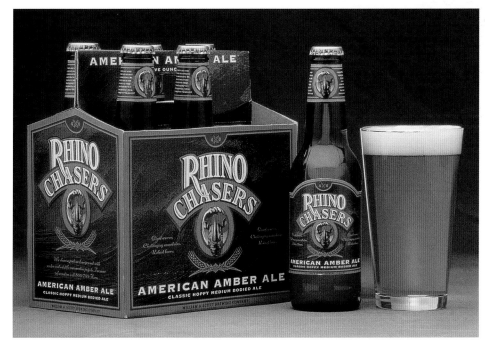

Rhino Chasers's new logo and packaging design project an image that mixes traditional rendering techniques with an edgy youthfulness.

LETTERHEADS AND LOGOS

Image Upgrade Celebrates Firm's Success

Firm: DBD International Ltd.

Art director: David Brier

Designer: David Brier

Client: Digital Minds/computer reseller

Problem: Client wanted an upscale look.

Digital Minds is a Minneapolis-based computer reseller that's done so well, its revenues have doubled every year for the past five years. As Digital Minds grew more and more successful and established a New York City office, its president felt it was time to upgrade to an image that demonstrated to current and potential clients that the company had arrived.

"The objective was to create an identity that completely communicated their savvy by its sheer presence," says David Brier, of DBD International Ltd., the design firm behind Digital Minds's new image. Brier expanded upon the icon the firm had previously used—a graphic reduction of a man's head—by producing a new logo and identity system that makes a vivid impression with four color and foil-stamping.

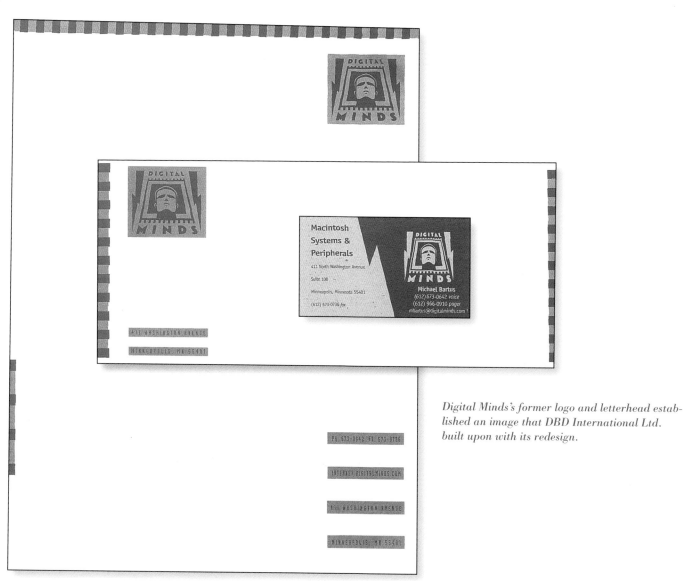

Digital Minds's former logo and letterhead established an image that DBD International Ltd. built upon with its redesign.

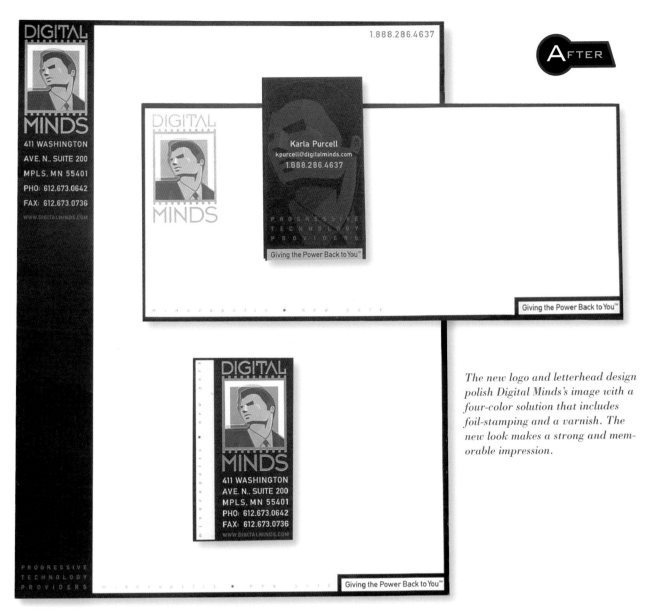

The new logo and letterhead design polish Digital Minds's image with a four-color solution that includes foil-stamping and a varnish. The new look makes a strong and memorable impression.

Brier first developed his version of the head that Digital Minds used as its central icon by rendering a four-color version on the computer and surrounding it with a frame that picks up the silicon chip border from the former identity. "Digital Minds" was set in a customized variation of the Insignia font and foil-stamped in silver, along with the illustration's frame.

A dramatic black background separates the logo and address line from the body of the letterhead and from the office locations on the business card, and it merges with a black border that appears on all of the company's identity materials. Varnish was applied to all components of the identity system to ensure that fingerprints wouldn't mar the appearance of the solid black background. The matte black and silver foil create a distinctive impression that's helped Digital Minds expand its business even further. "Our image says, 'Come to us, we know what we're doing,'" says Digital Minds president Michael Bartus. "Our new image shows that we're professionals."

New Identity Blends Nostalgia With Today

Firm: Sayles Graphic Design

Art director: John Sayles

Designer: John Sayles

Client: Barrick Roofing & Sheet Metal/roofer and supplier of architectural sheet metal

Problem: Client needed a strong, traditional look with a contemporary edge.

When Barrick Roofing & Sheet Metal's owners wanted their company's logo and letterhead redesigned, they knew they wanted a more contemporary look, but had little else in mind for their new image. "They asked me to keep it simple and to keep it one or two colors," says John Sayles, of Sayles Graphic Design, the design firm behind Barrick's new identity.

Sayles and his design team came up with a new logo that conveys the strength and stability one would expect of a roofing company and a family-owned business. The insignia format of the logo evokes a nostalgic look that supports Barrick's heritage of one hundred-plus years in the roofing business. Heavy black rules and type set in Copperplate Bold give the identity system a strong, industrial look.

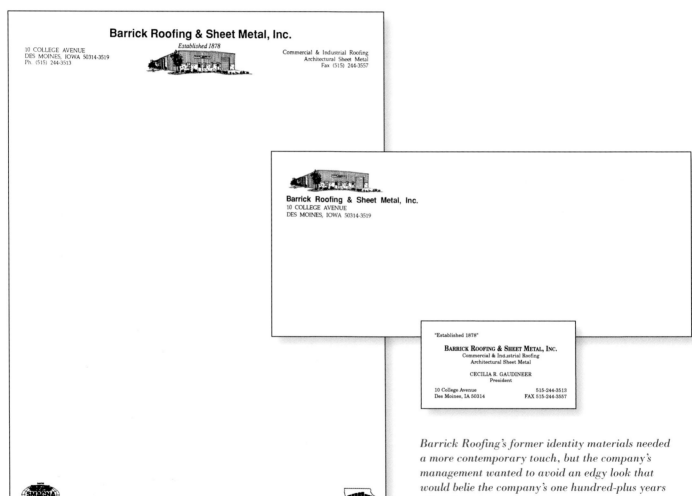

Barrick Roofing's former identity materials needed a more contemporary touch, but the company's management wanted to avoid an edgy look that would belie the company's one hundred-plus years of service.

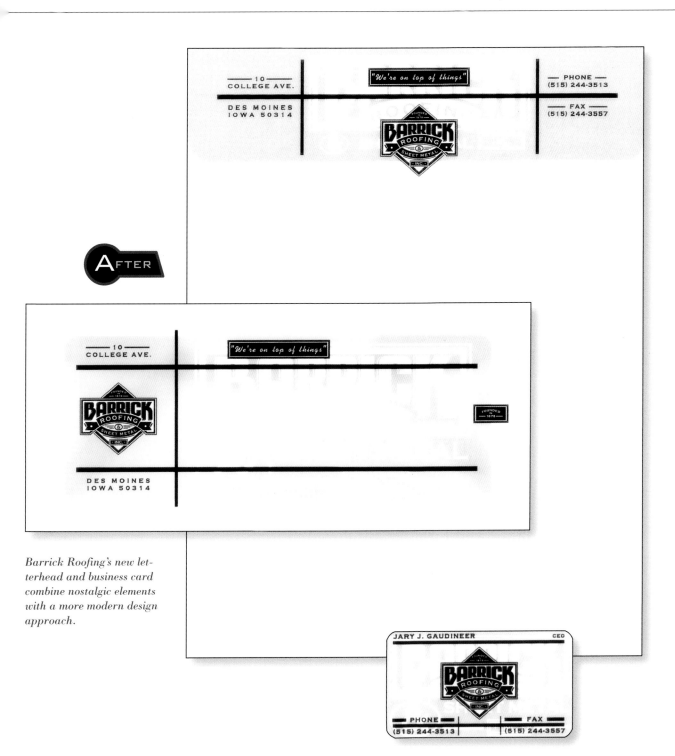

Barrick Roofing's new letterhead and business card combine nostalgic elements with a more modern design approach.

Sayles treated the insignia subtly, as a background element on Barrick's identity materials, by printing it in reverse in tan. The background image adds a contemporary edge to the identity system, while the insignia, printed on a smaller scale in black, establishes the company name with more authority. For graphic interest and humor, Sayles added a slogan, "We're on top of things," set in a vintage script typeface to complete the identity.

Conference Logo Is Customizable

Firm: Rickabaugh Graphics

Art director: Eric Rickabaugh

Designers: Eric Rickabaugh, Mark Krumel

Client: The Big East Conference/intercollegiate athletics

Problem: Existing logo didn't capture personality of the entire conference and was hard to customize.

The Big East Conference is a huge collegiate sports conference in which hundreds of college teams from thirteen schools participate, yet the conference's existing logo failed to reflect the national attention and excitement generated by Big East athletics.

"They wanted something that looked collegiate and was full of energy," says Eric Rickabaugh of Rickabaugh Graphics, the design firm behind the conference's new logo. To meet conference officials' request, his firm came up with a design with an optional starburst at its center. "It represents the energy of the conference as well as the rising sun of the east," says Rickabaugh. For a collegiate look, the logo's typographic approach makes use of a lettering style that simulates varsity letters. The new logo retains the original logo's red, white and blue color scheme plus an energizing gold for the logo's outline and optional starburst.

Because the conference includes over thirty team sports and thirteen colleges, the logo includes a banner that allows officials to customize it with the name of the sport or school. The logo's curvilinear shape also made it easy for Rickabaugh Graphics to further modify it for the Big East Conference basketball tournament.

"There are many different levels of use," says Rickabaugh of the new conference logo. In addition to appearing on stationery and promotional materials, the new logo is used on event signage, playing courts and fields as well as uniforms and retail merchandise such as hats and T-shirts.

The Big East Conference's former logo looked dated and failed to capture the excitement of the conference.

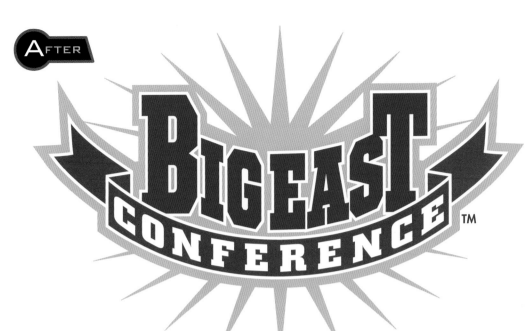

The new logo captures the energy and excitement of the conference and can be customized for each sporting event and school. Rickabaugh Graphics even came up with a version commemorating the conference's twentieth anniversary.

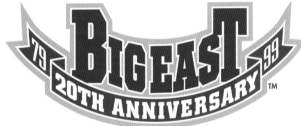

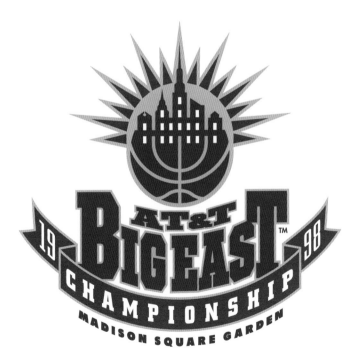

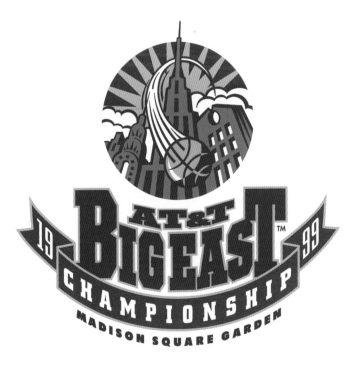

The Big East Conference basketball tournament captures national attention every year. Rickabaugh Graphics came up with logo designs for this event in 1998 (left) and 1999 (right) that merged the conference logo with basketball and the tournament's New York City venue.

New Identity Integrates Old and New

Firm: Evenson Design Group

Art director: Stan Evenson

Designers: Glen Sakamoto, Tricia Raven

Client: Reading Entertainment, Inc./theater chain and film producers

Problem: Client needed an identity that linked its former area of involvement with its new area of concentration.

How does a corporation with a history in one industry make the switch to another and convey both in its logo? Evenson Design, in Culver City, California, was faced with this challenge when Reading Entertainment (the "Reading" behind Reading Railroad) came to the firm wanting a logo that would effectively bridge this gap. Although the Reading Company had expanded from the railroad industry into entertainment, it still had considerable equity invested in its original logo from the 1860s. In fact, prior to Evenson Design Group's involvement, the original logo was used on all of Reading's business materials.

"They really didn't know how much of the history they wanted to show. We came up with everything from steam engines to engine smoke morphing into a filmstrip," says Stan Evenson of Evenson Design's range of fifty different design possibilities for Reading Entertainment's new logo. Evenson Design Group narrowed the possibilities to the top ten concepts to present to Reading executives, who selected one of them. "We came up with an *R* that is a metamorphosis of a railroad track into a filmstrip," says Evenson.

Reading Entertainment's former identity bore the logo that originated with the founding of Reading Railroad in the 1860s. Although it was steeped in tradition, the old logo didn't suit Reading's new role in the entertainment industry.

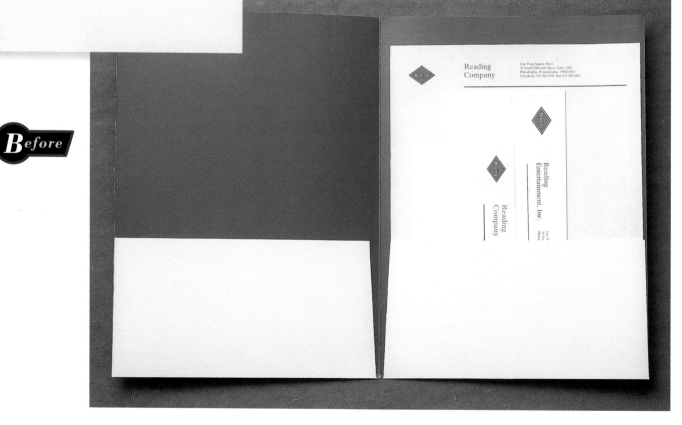

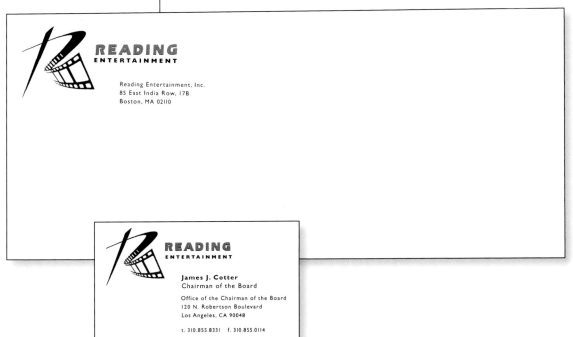

The production of the *R* was accomplished by scanning a rough sketch and developing a digital version that was refined in Adobe Illustrator. Because the logo would be used on everything from theater signage to business cards, Evenson Design produced both a small-scale version of the logo and a more detailed version, for large-scale applications such as exterior signage.

For letterhead and business cards, the distinctive *R* is used in combination with *Reading*, set in ITC Eras. To further reinforce Reading's roots, the old Reading logo appears as a watermark on the letterhead.

The new logo successfully weaves Reading's railroad history with its venture into filmmaking and entertainment.

Logo and Stationery Gets More Businesslike Look

Firm: Mortensen Design

Art director: Gordon Mortensen

Designers: Diana L. Kauzlarich, Gordon Mortensen

Client: Junglee Corporation/software manufacturer

Problem: Client wanted a more professional image.

The Junglee Corporation specializes in extracting information from the Web and repackaging it to serve the special needs of its clients. The company selected a name that reflects its ability to "tame" the Internet's information "jungle," hence the name Junglee, which means "wild" in Hindu.

The company's original logo projected a sense of wild, but Junglee's principals wanted a more businesslike look when they hired Mortensen Design—based in Mountain View, California—to develop a new logo. "We wanted to preserve the playfulness of the existing logo," says Mortensen Design principal Gordon Mortensen. "We were trying to walk that fine line between corporate and contemporary."

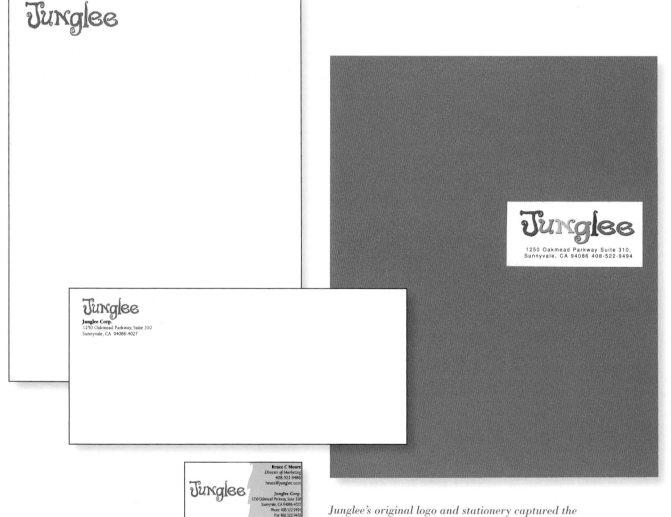

Junglee's original logo and stationery captured the look of the wild, but its multicolored, playful typography conveyed a look that wasn't in step with the businesslike image the high-tech corporation wanted to project.

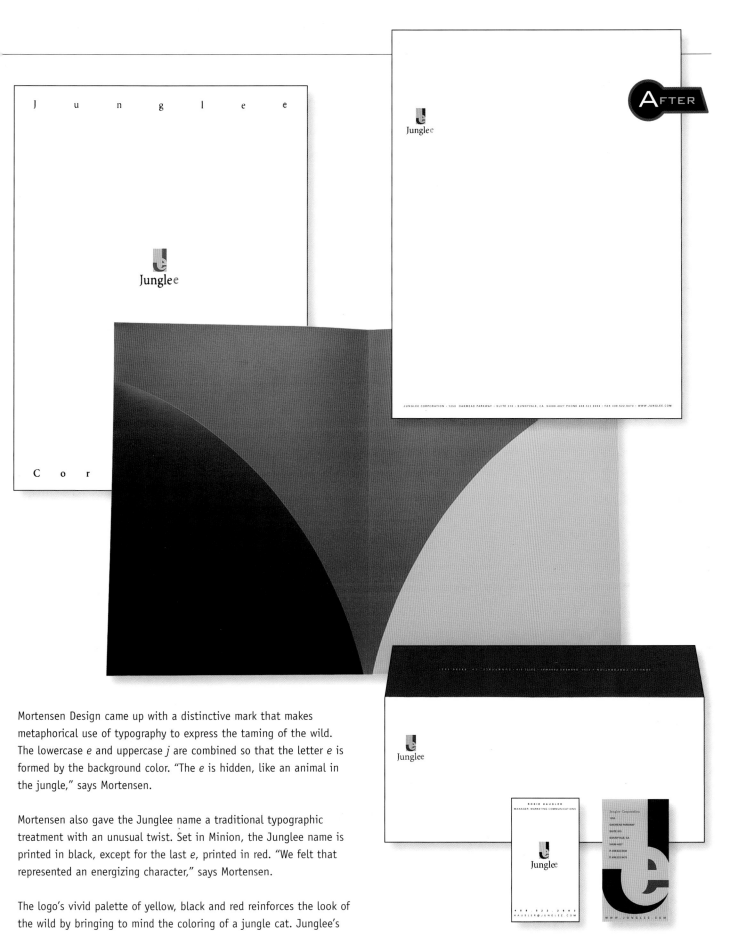

Mortensen Design came up with a distinctive mark that makes metaphorical use of typography to express the taming of the wild. The lowercase *e* and uppercase *j* are combined so that the letter *e* is formed by the background color. "The *e* is hidden, like an animal in the jungle," says Mortensen.

Mortensen also gave the Junglee name a traditional typographic treatment with an unusual twist. Set in Minion, the Junglee name is printed in black, except for the last *e*, printed in red. "We felt that represented an energizing character," says Mortensen.

The logo's vivid palette of yellow, black and red reinforces the look of the wild by bringing to mind the coloring of a jungle cat. Junglee's stationery is printed on Fox River Rubicon, a tree-free paper made from bamboo.

Junglee's new image projects a sense of playfulness while maintaining a businesslike demeanor.

Letterhead Design Picks Up on Poster Concept

Firm: Sayles Graphic Design

Art director: John Sayles

Designer: John Sayles

Client: The Greater Des Moines Good Times Jazz Festival/jazz festival

Problem: Client wanted a different look.

John Sayles of Sayles Graphic Design was faced with the challenge of dealing with an inordinate amount of copy when his firm took on the task of designing a new letterhead for the Greater Des Moines Good Times Jazz Festival. "There was the festival committee, the directors and the jazz partners," says Sayles of the long list of names that appeared on the Jazz Festival's previous letterhead. In addition, the Jazz Festival's dates and times needed to appear, plus their slogan, "Let the good times roll."

Rather than curse the copy, Sayles decided to embrace it through his use of various vintage typefaces. "I wanted it to look like old dance posters," says Sayles, who pasted together type specimens of alphabets he found in an old type catalog to form the central copy on the letterhead's red banner. Old-fashioned dingbats such as stars and a pointing finger enhance the look of old woodcut typography. The red banner also appears on the Jazz Festival envelope—with its right edge configured to resemble an admittance ticket—and fills an entire side of the new business card.

According to John Sayles, the Good Times Jazz Festival's officers asked for "something different" when his firm took on the job of redesigning the Jazz Festival's letterhead and business card.

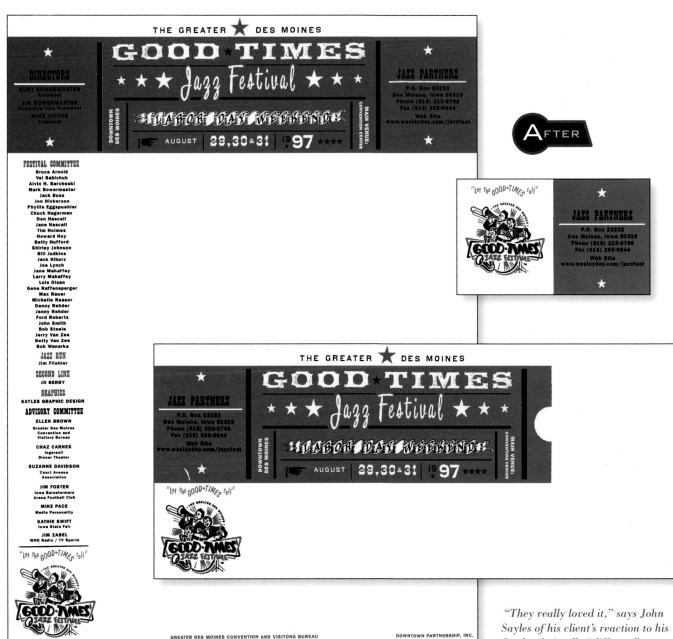

"They really loved it," says John Sayles of his client's reaction to his firm's admittedly "different" new design for the Good Times Jazz Festival's letterhead and business card.

The Jazz Festival's slogan is played up with an accompanying logo that features lively jazz instrumentalists. The illustration and lettering on the logo were hand rendered by Sayles.

Although Sayles created an old-fashioned pasteup for the information that appears within the banner, it was ultimately scanned and placed into position within QuarkXPress files that contained the type and other graphic elements that appear on the letterhead, envelope and business card.

Architects Get an Edgier Look

Firm: Grafik Marketing Communications

Art directors: Jonathan Amen, Gregg Glaviano

Designers: Jonathan Amen, Judy Kirpich, Gregg Glaviano, Regina Esposito

Client: Greenwell Goetz Architects/architectural firm

Problem: Client wanted a more contemporary image.

When Greenwell Goetz approached Grafik Marketing Communications about redesigning the company's logo and identity materials, Grafik Marketing Communications's designers initially took a traditional approach, developing a mark and logotype ideas they felt would best represent the company. But Greenwell Goetz's principals wanted an integrated look that would ensure that the company's personality would be communicated through all of its printed materials.

The designers decided to approach the project from a totally different vantage point. "Their logo was developed as a type treatment for the cover of their brochure," says designer Jonathan Amen, referring to the combination of rectangles and lines that frames the company's name. The logo is featured prominently on the cover of Greenwell Goetz's capabilities brochure as well as its sales kit cover (see pages 74–75).

Greenwell Goetz Architects, PC

Greenwell Goetz Architects, PC

James W. Greenwell, AIA, IIDA
Principal

1310 G Street, NW
Suite 600
Washington, DC
20005
202 682-0700
FAX 682-0738
jgreen@gga.com

1310 G Street, NW
Suite 600
Washington, DC
20005
202 682-0700
FAX 682-0738

Recycled paper for a better environment

Greenwell Goetz's identity materials, and particularly its black and red color scheme, were typical of those of other architectural firms.

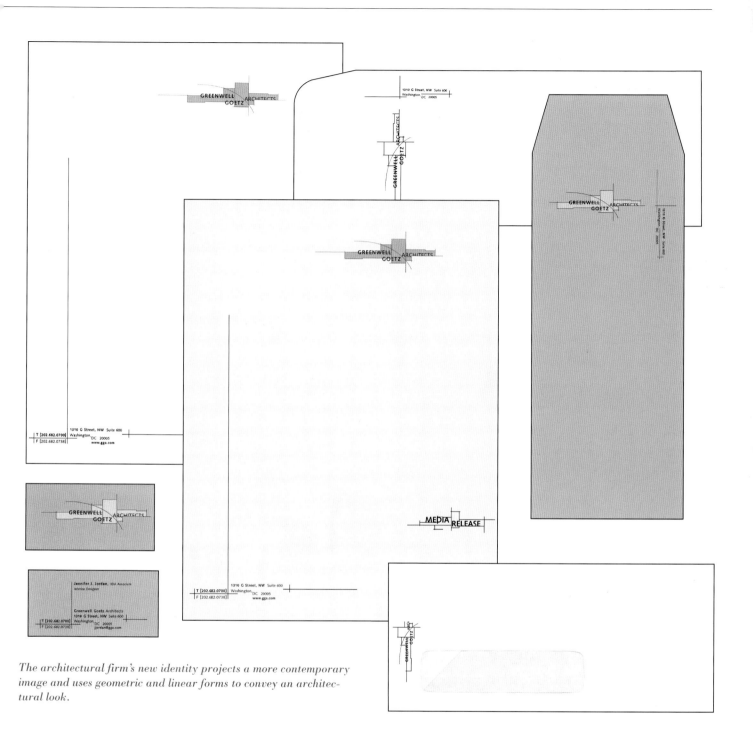

The architectural firm's new identity projects a more contemporary image and uses geometric and linear forms to convey an architectural look.

Amen used Syntax Regular and Bold for the company's name and other information and played up the logo's geometric look by incorporating additional lines into the designs for the other components of the identity system.

From there Amen developed a color palette of muted greens and blues that sets Greenwell Goetz apart from its competition. "I thought it was a bit edgier for them. The majority of architects use black and red," he explains. These new colors were carried into coordinated business papers that make creative use of a variety of paper stocks.

The envelope and business cards are made from French Frostone Frostbite. The background elements of the logo are printed in two hits of opaque white to contrast against the stock's dark, heathery tones. The company's media release form is printed on French Frostone Iceberg, while the letterhead is printed on Gilbert Neutech. For a rich contrast of textures, the background elements on both were offset printed, while the rules and typographical elements were engraved.

Logo Brings Out Organization's Nurturing Aspects

Firm: Bernhardt Fudyma Design Group, Inc.

Art directors: Janice Fudyma, Craig Bernhardt

Designer: Angela Valle

Calligraphy: Paul Shaw

Client: Partnership for After School Education (PASE)/children's advocacy group

Problem: Client wanted to upgrade its identity.

Partnership for After School Education (PASE) was formed by a group of parents, educators and other concerned individuals who wanted New York City's public-school children to have an after-school education program that would occupy them from the time school ended until their parents returned from work. When the organization was founded, the logo initially developed was used to get PASE off the ground.

Since then, PASE has become so successful that it now has its own office, full-time staff and board of directors. In recent years the organization's efforts have depended heavily on donations from local businesses. "They needed to upgrade the look of the organization—make it look more established—when they're soliciting donations from corporations that may be sponsors," explains Craig Bernhardt of Bernhardt Fudyma Design Group, Inc.

The logo PASE had been using was a sunset, which represented the time when school ends and PASE steps in. Because a versatile identity system had never been developed, the logo was often reinterpreted to fit specific applications by staff members who changed typefaces and the configuration of the name with its mark. This lack of consistency contributed to an image that lacked polish and professionalism.

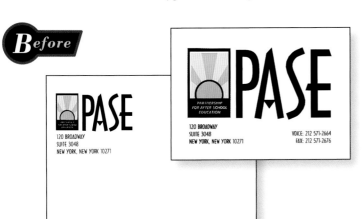

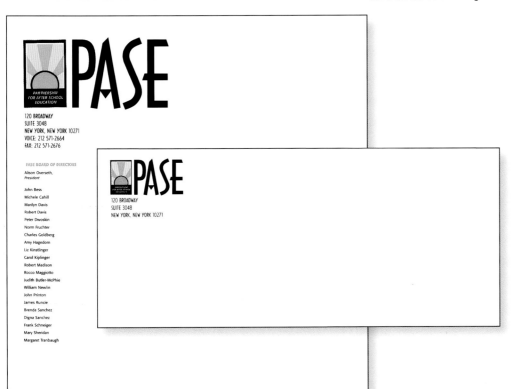

The original PASE logo depicted a sunset as a representation of the time when school ends and children need PASE-sponsored activities. The logo concept was often lost when viewers confused the sunset with a sunrise.

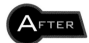

To best represent PASE's mission of helping and protecting children, Bernhardt and his design team decided to design a new logo that played up the human factor. "They wanted to get across that it's a mentoring situation," says Bernhardt. The firm developed a mark based on a loosely drawn representation of an adult and a child that together form the letter *P*.

In contrast with the spontaneous look of the mark, Bernhardt Fudyma Design Group, Inc. chose to set the PASE name in Thesis, a contemporary sans serif that adds a sense of tradition and stability to the organization's business materials. Bernhardt Fudyma proportioned the PASE name so that it supports rather than overpowers the mark. "We didn't make the use of the initials as dominant as it was before," says Bernhardt, noting that the acronym *PASE* says less about the organization than the symbol of the adult and child.

Photographer Gets Fashion-Oriented New Identity

Firm: Hornall Anderson Design Works, Inc.

Art director: Jack Anderson

Designers: Jack Anderson, Julie Keenan, Mary Chin Hutchinson

Client: Rod Ralston Photography/photographer

Problem: Client needed to update his image to appeal to a narrower audience.

In recent years, Ralston's business has increasingly gravitated toward fashion photography. Ralston's new logo and identity materials reflect this sensibility.

Jack Anderson, a principal of Hornall Anderson Design Works, Inc., had an opportunity to revisit an old project when he and his design team got involved in redesigning photographer Rod Ralston's logo and identity materials. "We had done his first mark," says Anderson, describing the pun on the Ralston Purina checkerboard his firm designed for Ralston in the late 1980s. "Back then photographers wanted to gain 'mind share' with designers by being clever," says Anderson.

Over time, Rod Ralston had grown and cultivated his business in a way that was gravitating increasingly toward fashion photography. To appeal to this market, Ralston wanted an identity with more sophistication and fashion appeal.

Hornall Anderson Design Work's solution was to create a distinctive mark that represents how a camera works. Inverting one of the *R*s in Ralston's initials compares and contrasts how an object looks to the naked eye as opposed to what happens when looking at it through a camera. "For those who don't get it, the logo still comes off as a clothing brand or a monogram for a designer," says Anderson. "For those who do, the design has a value-added double meaning."

The designers chose an elegant typeface as a basis for Ralston's mark. The letterhead's simple layout and subtle color palette of moss green and black completes the identity's sophisticated look.

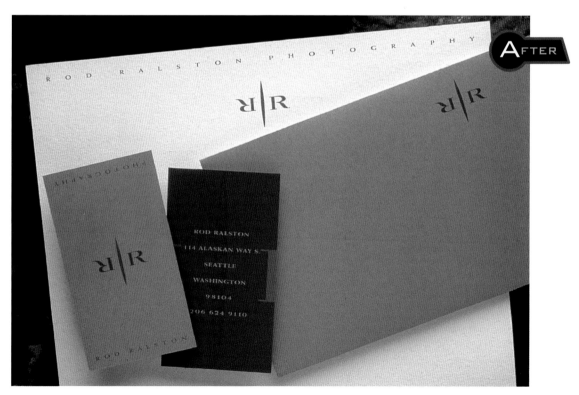

Rod Ralston's former identity was based on a visual pun of a camera combined with Ralston Purina's checkerboard square. The logo appealed to a general audience of designers and art directors in the late 1980s and early 1990s and helped Ralston build his business.

New Logo Draws Its Inspiration From M.C. Escher

Firm: DBD International Ltd.

Art director: David Brier

Designer: David Brier

Client: Phoneworks/telephone programming firm

Problem: Client wanted to upgrade its image.

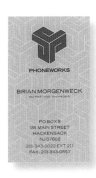

PO Box 9 • Hackensack, NJ 07602 • 201-343-0022

Phoneworks's previous stationery system was designed when the company was just a start-up. As the company grew more successful, the original image failed to reflect the stature it had attained.

The new identity system has a corporate look more appropriate for communicating with the company's Fortune 500 clients.

Phoneworks, a company that produces 1-800 and 1-900 phone systems, was working with a logo that had launched the firm; DBD International Ltd. was brought in to upgrade the firm's identity. "The logo was created by the president," says DBD principal, David Brier. "He's a strong entrepreneur—inventive and creative."

The old Phoneworks logo had sufficed when the company was starting up on a shoestring budget, but Phoneworks had grown to the point where a more corporate look and professional image were in order. "They've grown into a multi-million-dollar company servicing Fortune 500 companies," says Brier.

When Brier met with Phoneworks's president, he discovered the primary components of the company's business were phones, publishing and print. He also found that the president was a big fan of artist M.C. Escher. From there, Brier developed an icon formed by three interlocking *P*s. When the icon is multiplied, it forms an Escher-like pattern, which Brier used as a background element on Phoneworks's business card and a border on its stationery.

For a corporate look, Brier took a conservative approach, using a bold version of Trade Gothic Extended for the Phoneworks name and light versions of the font for other text on the stationery system. The identity's color palette of navy blue and gray supports the traditional look.

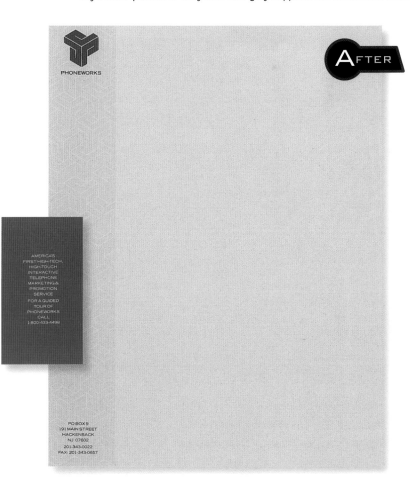

State Fair Identity Pushes the Envelope

Firm: Sayles Graphic Design

Art director: John Sayles

Designer: John Sayles

Client: Iowa State Fair/state fair

Problem: Client wanted a more cost-effective design solution.

The Iowa State Fair has made a practice of coming up with new letterhead and business materials every year to launch each fair as an event with its own unique slogan and identity. Until recently, the State Fair's marketing department hired an advertising agency to develop a new design every year. But in 1997, that practice changed when Des Moines-based Sayles Graphic Design was given the nod for the project. "They realized that they really didn't need an agency. What they needed was a design firm," says firm principal John Sayles, adding that the marketing expertise the State Fair previously paid for was already being provided by its own marketing department.

Sayles Graphic Design was able to provide a more cost-effective design solution that exhibited just as much, if not more, design savvy than the Fair's previous identities. The firm's approach to the project was to use graphics to emphasize fun at the fair. "The fair is supposed to be fun," says Sayles. "Whatever we did, it had to be fun and different."

Sayles Graphic Design's concept for the 1997 Fair features a hand-drawn ear of corn and a playful typographic treatment that incorporates images from the fair into letterforms. The following year, the firm played up the fair's slogan—"Way Too Much Fun!"—with hand-lettered typography and a palette of electric colors. The 1999 approach again focuses on the fair's slogan—"Knock Yourself Out"—which is rendered with a suitably "walloping" graphic treatment.

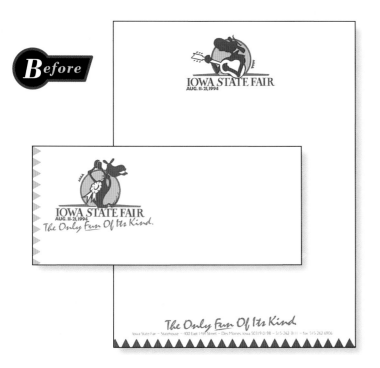

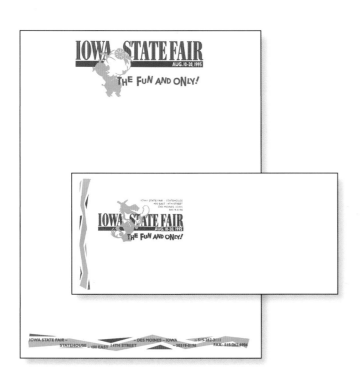

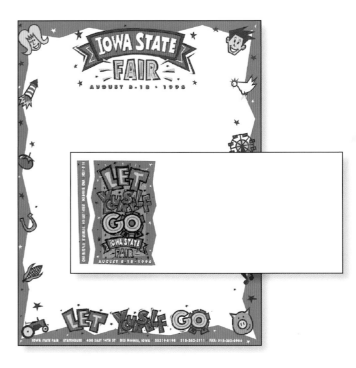

The Iowa State Fair has always tried to project a fun-filled image with its letterhead and other business materials.

Sayles has been the art director and principal designer on all three Iowa State Fair designs and rendered all of the illustrations and typography involved. Sayles explains his involvement: "It's a high-visibility thing, and I feel like I'm giving back to the community." The project also gives Sayles the opportunity to flex a lot of creative muscle. "We've challenged the client, ourselves and the post office," says Sayles, who admits that at least one of his state fair envelope designs needed to be adjusted to accommodate mailing standards. The plus side is that his client has been so pleased, Sayles has been encouraged to take even greater design risks. "The client is at the point where they're saying, 'Can you push it a little further?' I think that's great," says Sayles.

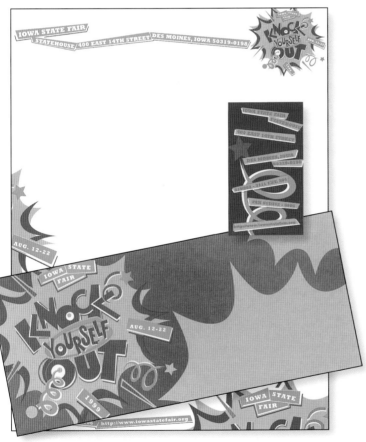

Sayles Graphic Design's approach stresses fun with playful, hand-rendered typography.

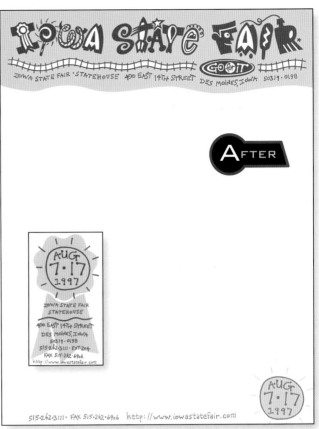

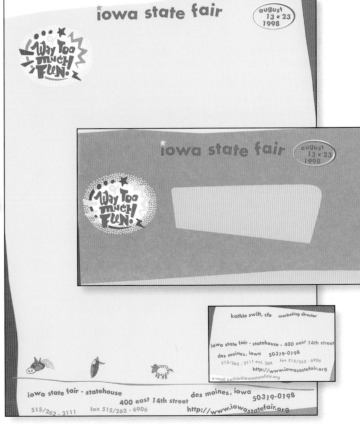

Financial Group Softens Image

Firm: Mortensen Design

Art director: Gordon Mortensen

Designers: Gordon Mortensen, Wendy Chon

Client: Kitcole/financial advisor

Problem: Client wanted to appeal to a female clientele.

Kit Cole, president of Cole Financial Group—based in San Rafael, California—wanted to reposition her company as a female-friendly investment advisory service when she hired Mortensen Design to redesign her firm's identity. She had decided on changing her company's name to "Kit Cole," and she wanted a new logo and stronger image to introduce her company to its new target market.

"The two words were so short, I didn't like the space between them," says Gordon Mortensen, of Mortensen Design, of the new company name. By merging the first and last names Mortensen created one word. A subtle separation is indicated by printing *kit* in black and *cole* in teal. "It's more unique as a company name," he explains. Mortensen also chose to set the name in Minion in all lowercase letters for a more approachable look. "It makes it less formal," he states.

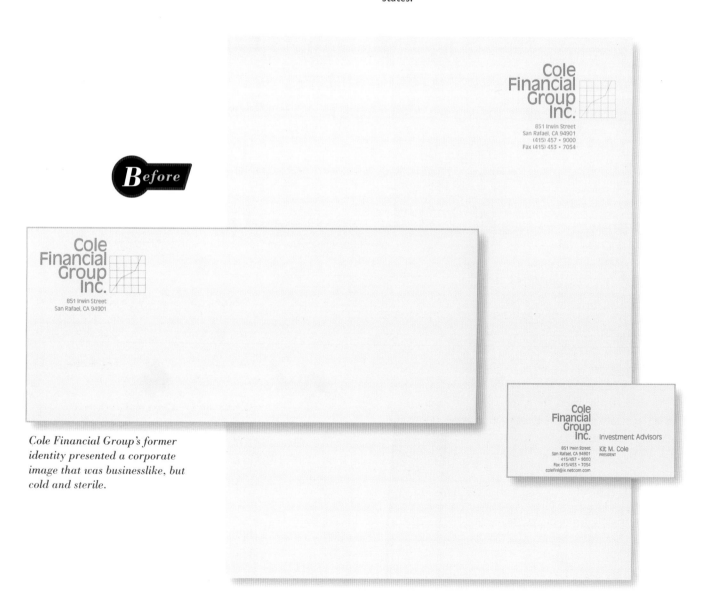

Cole Financial Group's former identity presented a corporate image that was businesslike, but cold and sterile.

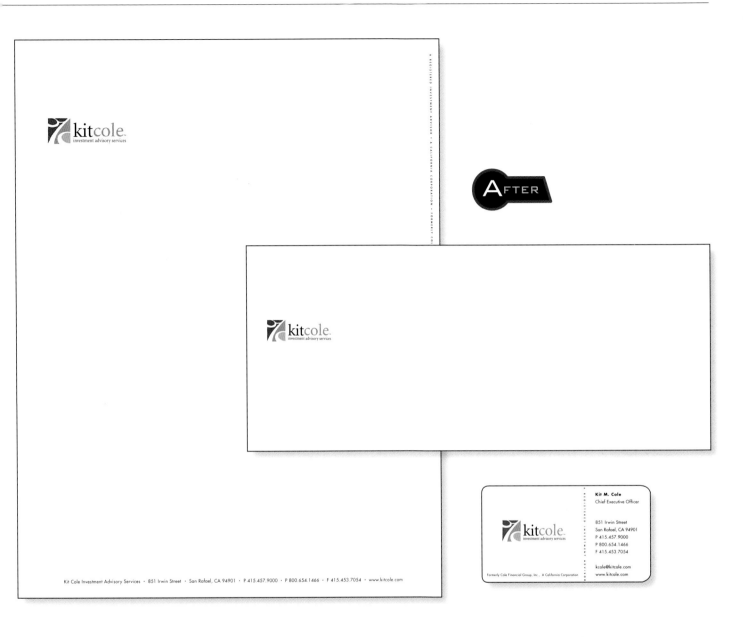

The Kitcole mark is an abstracted percent symbol, drawn as a pencil sketch and then scanned and refined on the computer in Macromedia FreeHand. Mortensen Design chose the percent symbol because investment advisors work to produce a "percentage of return—high yield. It also forms the initials *kc*," Mortensen observes. The mark is treated in a way that puts its recognition value somewhere between the abstract and the recognizable. Of the symbol's palette of teal, black and gold, Mortensen says, "When you're investing people's money, they need to take you seriously." Mortensen feels the limited application of bright color brightened the logo without making it appear flamboyant.

Mortensen Design's combination of a conservative typography and unusual color create a look that's businesslike, yet approachable. To complement the serif typography of the Kitcole name, a sans serif typeface, Futura, was chosen for the address line and phone number on Kitcole's letterhead.

Kitcole's new logo and stationery system project a more approachable image.

"She did some research and discovered that female customers like rounded as opposed to angular shapes," says Mortensen of his client Kit Cole. As a result, Kitcole's business cards were die cut with round corners.

Convention & Visitors Bureau's Identity Captures West Hollywood's Personality

Firm: Smullen Design Inc.

Art director: Maureen Smullen

Designers: Maureen Smullen, Bret Chambers, Jim Brazeale

Illustrator: Maureen Smullen

Client: West Hollywood Convention & Visitors Bureau/convention and visitors bureau

Problem: Former identity failed to capture the city's character.

Although West Hollywood Convention & Visitors Bureau's business and promotional materials proclaimed West Hollywood as "the Creative City," the city's former identity didn't project a very creative image. "It could've been any city," says Maureen Smullen, referring to the screened-back aerial view of a major West Hollywood thoroughfare that represented the Convention & Visitors Bureau on its letterhead and other business materials.

As principal of Smullen Design Inc., Smullen led her firm in the redesign of the Convention & Visitors Bureau's identity. She sought to capture West Hollywood's rich and diverse character in its logo, where each letter of *West* in *West Hollywood* is set in a different typeface and placed in its own rectangle. The overlapping rectangles recall the billboards that are so much a part of West Hollywood's famed Sunset Strip.

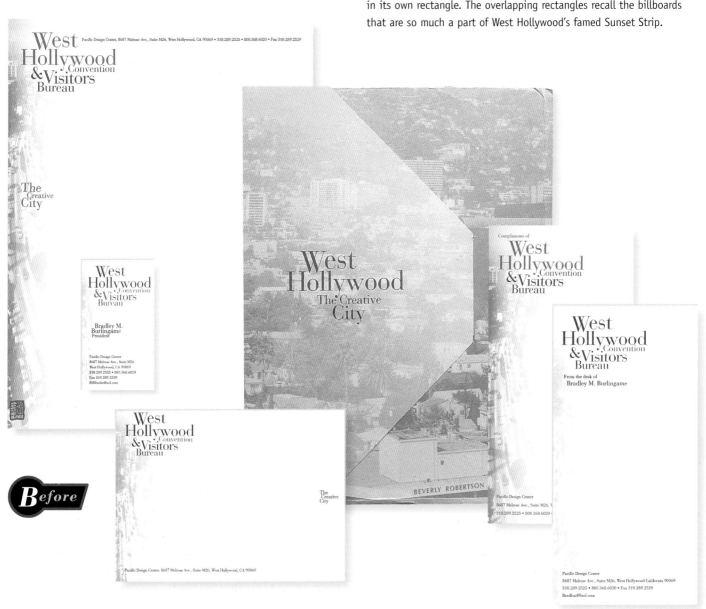

West Hollywood Convention & Visitors Bureau's former identity projected a contemporary, professional image, but failed to capture the unique flavor of West Hollywood.

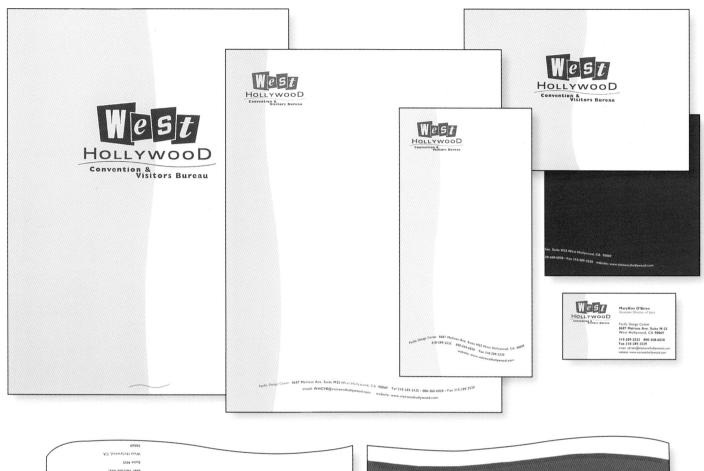

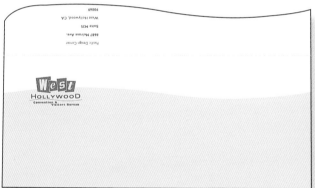

The new identity uses color, typography and graphic elements to represent West Hollywood's terrain, climate and personality.

The curvilinear margins that appear on the stationery and business card and the curvy rule under *Hollywood* reflect the configuration of the city's hills. Even the identity's palette of rust, navy and warm yellow suggests the area's warm, sunny climate.

In addition to a full complement of business materials that includes stationery, business and note cards and labels, Smullen Design Inc. also designed a pocket folder that's used by the Convention & Visitors Bureau to mail brochures and other information about the city's facilities.

"We needed to single out West Hollywood as a distinct, easy-to-reach destination for both the business and pleasure traveler," says Brad Burlingame, president of the Bureau. Smullen Design Inc.'s new identity accomplishes this by capturing West Hollywood's personality and setting it apart from other cities in the Los Angeles area.

New Letterhead Stays in Step With Changing Times

Firm: Sayles Graphic Design

Art director: John Sayles

Designer: John Sayles

Client: American Marketing Association,
Iowa chapter/professional organization

Problem: Client wanted to appeal to a younger audience.

Officers of the Iowa chapter of the American Marketing Association (AMA) wanted an image change when they approached John Sayles of Sayles Graphic Design about redesigning the organization's letterhead. "They were trying to attract a younger crowd," says firm principal John Sayles, noting that the local AMA chapter and other local professional groups were competing for members.

Sayles and his design team decided to depart from using the AMA national logo, formerly used on the Iowa Chapter's letterhead. Instead they developed a circular seal with "American Marketing Association" rendered in a circular format. At a distance the seal looks official, but closer inspection reveals that it flies in the face of convention. "I wanted it to be almost illegible," says Sayles of the raw, hand-scrawled typography he used. Sayles also drew the crest at the circle's center bearing the Iowa banner.

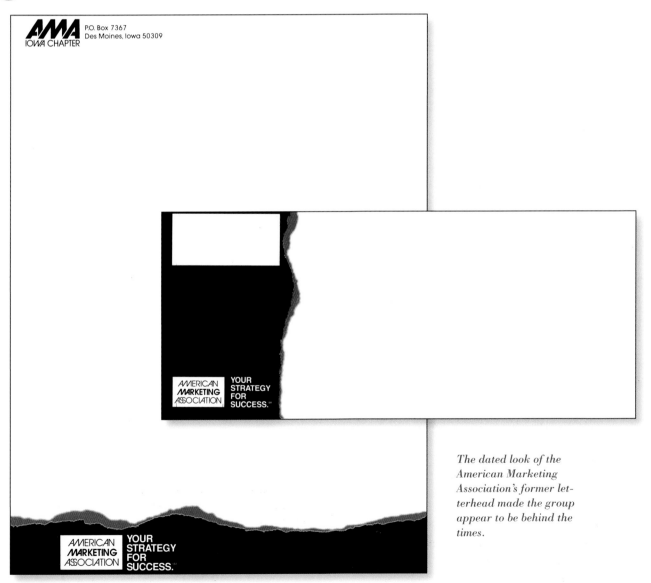

The dated look of the American Marketing Association's former letterhead made the group appear to be behind the times.

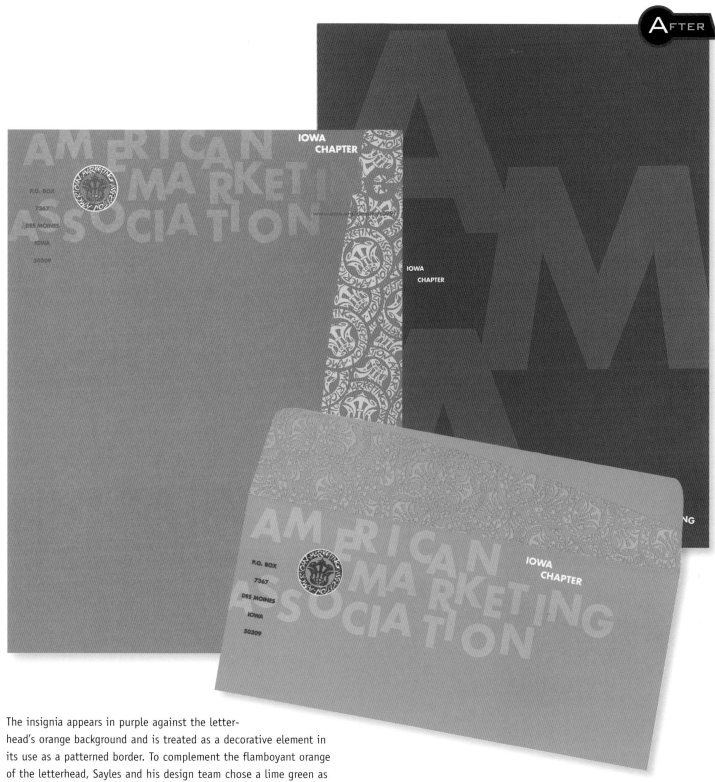

The insignia appears in purple against the letter-head's orange background and is treated as a decorative element in its use as a patterned border. To complement the flamboyant orange of the letterhead, Sayles and his design team chose a lime green as the dominant color for the envelope.

Given the edgy treatment of the AMA's name in its new insignia, Sayles decided to reinforce the AMA name by setting it unevenly in Futura Extra Bold. Its large scale ensures legibility even though it's printed in a screen tint of the same colors used on the background of the letterhead and envelope.

Sayles Graphic Design used unexpected colors to give the AMA's new letterhead a more contemporary look and created an edgy, unorthodox seal that invites a second glance.

Beckett Specs a New Look

Firm: Petrick Design

Art director: Robert Petrick

Designers: Robert Petrick, Laura Fox

Client: Beckett Papers/paper manufacturer

Problem: New logo was needed as part of an overall effort to update the company's image.

Beckett Papers realized it needed to update its way of marketing papers to graphic arts professionals, so it invited designers from across the country to evaluate its promotional materials. One of the participants, Robert Petrick of Petrick Design, not only helped critique Beckett's efforts, but also impressed Beckett executives with his input. They hired him to help them in their redesign of Beckett's swatch books and logo.

Beckett had been using a logo—a design of an abstracted buckeye leaf—that dated back to the 1970s. The design was based on

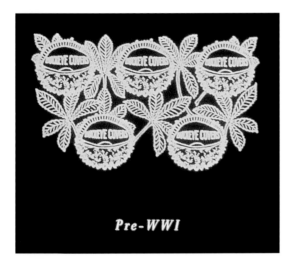

Pre-WWI

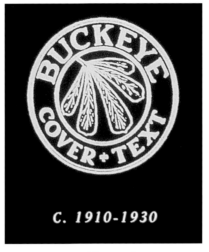

C. 1910-1930

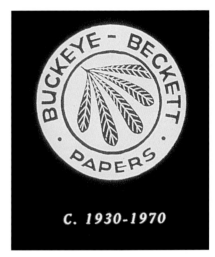

C. 1930-1970

Beckett's original logo and company name were based on Beckett's origins in Ohio, where the buckeye is the state tree. Over the years, the buckeye continued to be the basis of Beckett's corporate mark, even though the company name eventually became "Beckett."

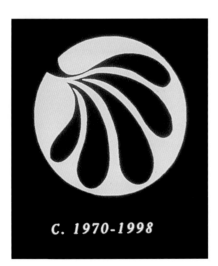

C. 1970-1998

Beckett's former logo, designed in the 1970s, looked dated and was based on an association with the paper manufacturer's local origins. The abstract symbol no longer had meaning within the context of Beckett's present status as an international corporation.

Beckett.™ Spec It.

Beckett's new logo makes a connection with its past with a mark that shares the same circular format as the logos that preceded it. The "Spec It" tag line sends a message on Beckett's promotional materials.

Beckett's connection with Ohio, the "Buckeye State," where the company was founded. "By that point, they were operating on a national scale, and the importance of the buckeye leaf wasn't there any more," says Petrick. "They went with an abstract shape that was very much in vogue during the 1970s."

Since then, Beckett had been bought by International Paper and now has mills outside of Ohio. The connection with the Ohio buckeye no longer had any meaning. "We wanted to make some connection with the past, but we also wanted to bring some meaning to the logo," Petrick explains. "That's when we hit on the idea of turning it into three sheets of paper." The three sheets represent Beckett's lines of writing, text and cover papers. The direction of the papers' curve and the logo's circular format bridge the connection with Beckett's former logo.

Petrick chose to maintain a serif typeface for "Beckett," but switched to Perpetua, which he describes as "more refined." Petrick was able to convince Beckett to drop the word *paper* from its name. "It makes it a stronger brand," says Petrick. The shortened name also allowed Petrick to come up with the "Spec It" tag line that appears after the Beckett name on promotional materials.

Design Firm "Bests" Its Former Identity

Firm: Viva Dolan Communications and Design

Art director: Frank Viva

Designer: Frank Viva

Client: Viva Dolan Communications and Design/design firm

Problem: A new look was needed to maintain a fresh image.

Before

A great act is hard to follow. Frank Viva of Viva Dolan Communications and Design found this maxim to be true when faced with the daunting prospect of redesigning his firm's identity.

Viva Dolan Communications and Design's innovative and variable identity system, based on a series of stickers, had served the company well since its inception six years ago, winning awards and even spawning imitators. Yet Viva felt the firm's original identity was beginning to look dated.

He got the idea of using the firm's initials as the basis for a new logo design. "Since we started, people were calling us 'VD' somewhat endearingly," he explains. "I decided it would be fun to make fun of that and embrace it, as opposed to fighting it."

Viva Dolan Communications and Design's former identity was based on a series of stickers. Although the variety of possibilities made for a lively identity system, after six years designer Frank Viva felt the look had grown stale.

The flaming VD mark was achieved by photographing three-dimensional letters while they were on fire. To achieve realistic results, Viva supplied the metal letters, salvaged from an old building, and squirted lighter fluid on them before igniting them. Against a white backdrop, Hill Peppard (the photographer) shot hundreds of frames of the flaming VD from various angles. The photo that Viva Dolan chose was shot from above while the burning letters were laid flat.

As a foil for the three-dimensional, colorful flamboyance of the VD mark, Viva used a simple layout and typographic approach for the Viva Dolan name and other information on the firm's business materials. "The logo was so exuberant, I felt I needed to counterbalance it," he states.

Along with with digital art for the pieces constituting the identity, the photograph was furnished as a slide to the printer. After a high-resolution scan was made, the background was knocked out to create a seamless transition to the background of Viva Dolan Communications and Design's letterhead and business materials.

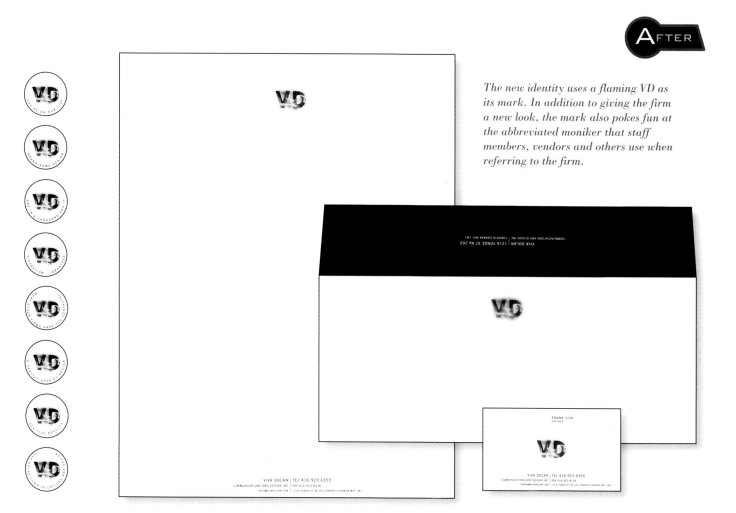

The new identity uses a flaming VD as its mark. In addition to giving the firm a new look, the mark also pokes fun at the abbreviated moniker that staff members, vendors and others use when referring to the firm.

The new logo design is also printed on stickers that are placed in a debossed indent at the center of Viva Dolan Communications and Design's hardbound proposal covers. "We'll choose a sticker that's appropriate for a particular client. We also use them on the back of envelopes," says Viva.

Multi-Million-Dollar Firm Upgrades Its Image

Firm: Evenson Design Group

Art director: Stan Evenson

Designers: Glen Sakamoto, Tricia Raven

Client: FD Titus & Son, Inc./medical and pharmaceutical supply distributor

Problem: Image didn't fit company's professional and financial status.

Titus & Son is a major dealer of medical and pharmaceutical supplies in the greater Los Angeles area. When Titus's executives contacted Stan Evenson of Evenson Design Group about an identity makeover, Evenson immediately noticed that the company's image didn't match its corporate status. "They're a fifty-million-dollar company," says Evenson. Yet Titus's logo and business materials projected the image of a small-scale family-owned business.

Evenson also took note of the strength in the Titus name and learned that the company was commonly referred to by its clients as "Titus," as opposed to the full FD Titus & Son name. Before Evenson and his design team got started on Titus's identity redesign, they suggested that their client drop *FD* and *Son* from the logo and develop a logotype based on *Titus*. "It was very easy to convince them of that," says Evenson.

Before

The original identity of FD Titus & Son made use of the company's entire name in its logotype. The approach conveyed a small-scale and unsophisticated image.

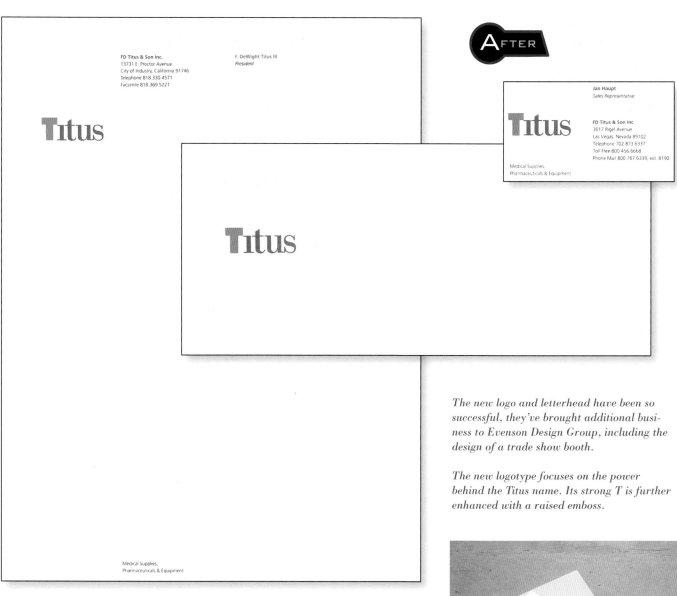

FD Titus & Son Inc.
13731 E. Proctor Avenue
City of Industry, California 91746
Telephone 818.330.4571
Facsimile 818.369.5221

F. DeWight Titus III
President

Titus

Titus

Medical Supplies,
Pharmaceuticals & Equipment

Jan Haupt
Sales Representative

Titus

FD Titus & Son Inc.
3017 Rigel Avenue
Las Vegas, Nevada 89102
Telephone 702.873.6337
Toll Free 800.456.6668
Phone Mail 800.767.6339, ext. 8190

Medical Supplies,
Pharmaceuticals & Equipment

The new logo and letterhead have been so successful, they've brought additional business to Evenson Design Group, including the design of a trade show booth.

The new logotype focuses on the power behind the Titus name. Its strong T is further enhanced with a raised emboss.

From there, Evenson Design Group developed a design solution that plays up the strength of the Titus name with a bold, sans serif *T* printed in teal and embossed so it stands out from the other components of Titus's letterhead. To contrast with and counterbalance the heaviness of the powerful *T*, the design team set the remaining characters of the Titus name in Bodoni Bold. Although the Titus letterhead and business card still say "FD Titus & Son," that name appears above the address line as opposed to being part of the Titus logotype.

Evenson says the logotype's straightforward approach seemed to make the dot on the letter *i* in *Titus* unnecessary. "We really wanted a tight fit of the *T* integrating with the *i*," he states. In addition to removing the dot on the *i*, all of the letterforms were tweaked, according to Evenson, "to give Titus complete ownership of this logotype."

Four-Color Gets Subtle

Firm: DBD International Ltd.

Art director: David Brier

Designer: David Brier

Calligraphy: David Brier

Client: West Wind Graphics/commercial printer

Problem: Client wanted a more contemporary and colorful image.

When West Wind Graphics, a printing company located in Menomonie, Wisconsin, got a new press, its principals felt it was time to upgrade the firm's image. "They wanted something that would use color," says David Brier, of DBD International Ltd., the design firm behind West Wind Graphics's new identity system.

Brier felt the firm needed an emblem as opposed to a logotype, which they had used since their founding in 1982. The emblem approach also helped Brier deal effectively with the company's long name, allowing him to wrap it around a circular format.

Using a drawing program, Brier created a monogrammatic *W* to place in the center of the circular emblem. "The letter *W* is a very beautiful letterform, if you know what to do with it," Brier explains. Starting with the typeface Trajan for the circular type, Brier created a custom drawn *W* that's shaded to give the impression of a letterform chiseled in relief. The loop adds a custom touch and helps the *W* fill the space in the center of the circle.

West Wind Graphics's old logo and letterhead hadn't been redesigned since the printer's establishment in 1982. The old identity looked dated and lacked color.

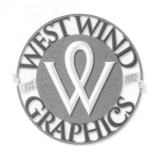

406 TECHNOLOGY DRIVE WEST, MENOMONIE, WI 54751
TELEPHONE:715-235-1104 FACSIMILE:715-235-1184
E-MAIL:WESTWIND@WWW.WIN.BRIGHT.NET
WWW.WIN.BRIGHT.NET/~WESTWIND

406 TECHNOLOGY DRIVE WEST, MENOMONIE, WI 54751

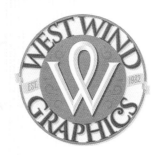

Charisse Sutliff
RECEPTIONIST

406 TECHNOLOGY DRIVE WEST
MENOMONIE, WI 54751
TELEPHONE:715-235-1104
FACSIMILE:715-235-1184

West Wind Graphics's new identity system takes advantage of the printer's four-color capability in a subtle way. Its logo, an emblem with a monogram at its center, is featured prominently in a layout that looks "designed" without being overpowering.

Because West Wind Graphics services many graphic arts professionals, Brier strove to create an aesthetic look as opposed to a conservative, corporate approach. The opportunity to use four-color process as a chance to flaunt brightly colored graphics was a possibility Brier rejected in favor of a more subtle palette of a muted blue-green, violet and peach. The result is a sophisticated image that also appeals to those with an eye for good design.

New Logo Has the Look of Appliance Dials

Firm: Sayles Graphic Design

Art director: John Sayles

Designer: John Sayles

Client: Goodwin Tucker Group/servicer of restaurant equipment

Problem: Client wanted an image that was more contemporary.

When the Goodwin Tucker Group came to Sayles Graphic Design seeking a new identity system, they wanted a more contemporary look. The servicer of restaurant equipment got a bonus when the design firm came back with a logo that not only looks contemporary, but also conveys a sense of the company's business.

"The G at the beginning of *Goodwin Tucker* could be a dial on a stove," says John Sayles of Sayles Graphic Design. The logo design also makes use of lines and circles to suggest other dials and controls on an appliance panel. The circular format of the logo is complemented by the full circle Os in the Goodwin name—the result of using Futura for the typography on the letterhead and business card.

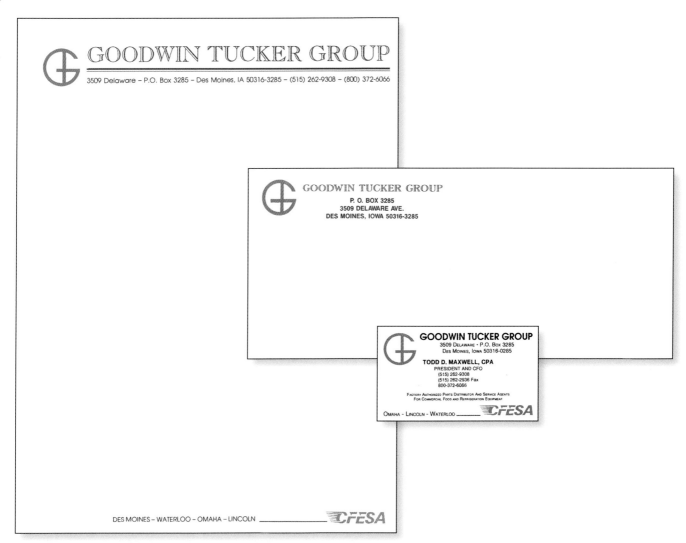

Goodwin Tucker Group's previous identity system looked dated and failed to project any sense of the company's business.

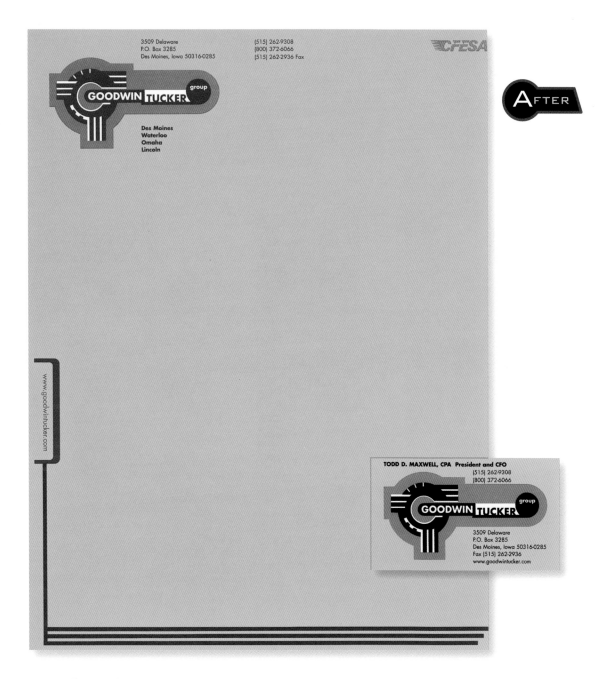

3509 Delaware
P.O. Box 3285
Des Moines, Iowa 50316-0285

(515) 262-9308
(800) 372-6066
(515) 262-2936 Fax

CFESA

GOODWIN TUCKER group

Des Moines
Waterloo
Omaha
Lincoln

www.goodwintucker.com

TODD D. MAXWELL, CPA President and CFO
(515) 262-9308
(800) 372-6066

GOODWIN TUCKER group

3509 Delaware
P.O. Box 3285
Des Moines, Iowa 50316-0285
Fax (515) 262-2936
www.goodwintucker.com

The new identity ties in with Goodwin Tucker Group's business—servicing restaurant equipment—by featuring a logo that draws its inspiration from the dials on kitchen appliances.

The identity system's bright palette of red, yellow and black was partly conceived in response to the client's request to develop a look that would "be noticed." Sayles also got a notion of what his client might like from observing Goodwin Tucker Group's trucks, which are painted bright yellow with red lettering. Since the redesign, the new trucks have been repainted with the new logo and identity typestyle.

New Logo Design Takes a Good Idea and Makes It Better

Firm: Rickabaugh Graphics

Art director: Eric Rickabaugh

Designer: Dave Cap

Client: ULD Deliverymen/on-campus dry-cleaning and laundry service

Problem: Client wanted a logo more specific to its business.

Deliverymen, an on-campus dry-cleaning and laundry service, had been doing business with a nicely designed logo that used strong, italicized type and a rider on horseback to communicate the chain's speedy pickup and delivery capabilities. However, the company's owners wanted a logo that would more accurately portray the business. "They wanted to get across that it's a laundry and dry-cleaning service and that their delivery people are dispatched via cell phones," says Eric Rickabaugh of Rickabaugh Graphics, the design firm behind ULD's new logo. "We brought all of it together with the image of the running deliveryman with the cell phone and shirt."

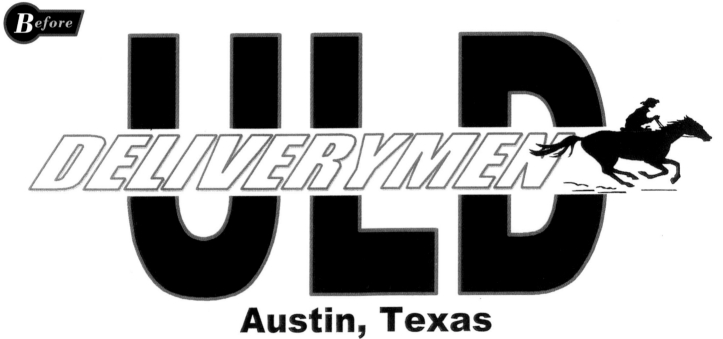

The former logo of ULD Deliverymen was designed by its owners.
Although capably handled, the design wasn't as specific to the
on-campus dry-cleaning and laundry service as its owners wanted it to be.

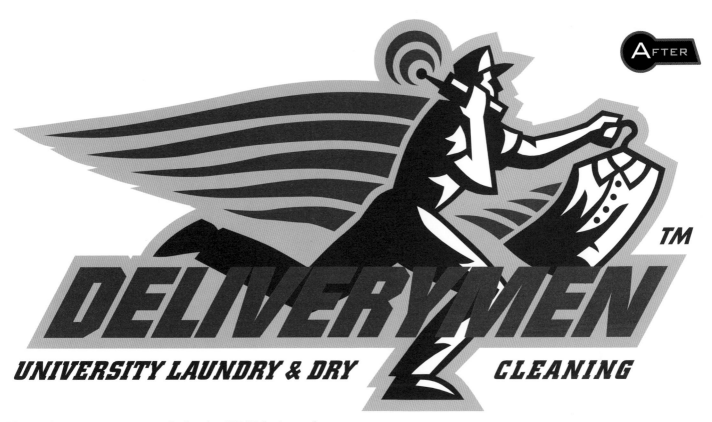

The new logo communicates specific details of ULD's business: the on-campus dry-cleaning and laundry service offers speedy pick-up and delivery via cell phone-dispatched drivers.

Rickabaugh Graphics's new design makes use of the same italicized version of Machine Bold for "Deliverymen" that was used on ULD's former logo, a benefit that Rickabaugh acknowledges brought some continuity between the old and new. But the color palette for the new logo is a marked departure from the old. Rickabaugh says his client wanted to retain the red used in the old logo's color scheme of red, white and blue, but he discouraged them from sticking with the same colors in favor of a more unique look. "We're asked to do so many logos that are red, white and blue," he relates. "We try to steer clients away from that." Instead, Rickabaugh and his design team used red, blue and yellow, a combination that helps the blue and white delivery-man stand out from his red and yellow "winged" background.

In addition to letterhead and business forms, the new logo appears on signage, trucks, uniforms and advertising.

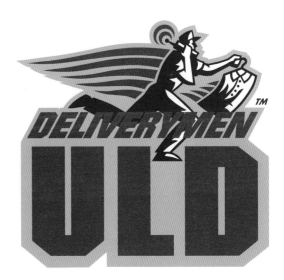

On some campuses, ULD Deliverymen goes by just ULD. For these locations, Rickabaugh Graphics created another version of the logo that plays up the ULD.

Brochures and Sales Kits

Architects' Sales Kit Showcases Design Firm's Capabilities

Firm: Grafik Marketing Communications

Art directors: Jonathan Amen, Gregg Glaviano

Designers: Jonathan Amen, Gregg Glaviano, Judy Kirpich, Regina Esposito

Photographer: Thomas Arledge

Client: Greenwell Goetz Architects/architectural firm

Problem: Client wanted a customizable sales kit.

Greenwell Goetz Architects's former sales kit didn't match the architectural firm's creative architectural concepts.

Designing a sales kit for an architectural firm can be a designer's dream come true—a four-color budget and great visual material. But it can also bring challenges—showcasing creative material demands an exceptionally creative concept.

The designers at Grafik Marketing Communications met this challenge successfully when the firm was hired to create a sales kit for Greenwell Goetz Architects. The sales kit was part of the architectural firm's image makeover, which also included a new logo and identity materials (see pages 46–47).

The designers at Grafik Marketing Communications brought the identity's color palette of muted greens and blues into the sales kit design. The lines of the logo, featured on the cover, are extended into a grid configuration that enhances the logo's architectural look. The cover's geometric graphic treatment contrasts with its curvilinear die cut, repeated on the folder's interior pockets. Grommets and other industrial materials enhance the sales kit's feeling of structure and building materials.

The kit is actually a three-tiered system that allows Greenwell Goetz to promote itself at a minimal cost at trade shows, while attaining a more expensive look to impress its more demanding clients. The system is also modular, consisting of a series of four-color project sheets. For large-scale distribution, a four-color capabilities brochure is tucked

The new sales kit does more than look creative; it's a modular system of materials that can be mixed and matched to create custom packets.

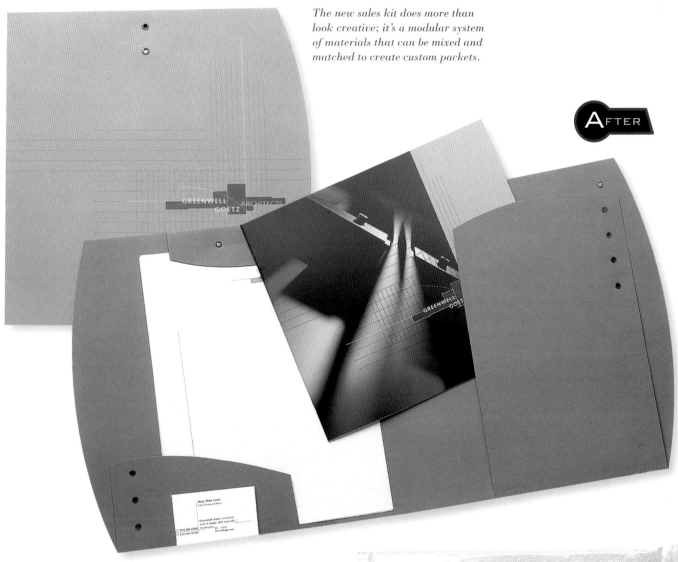

AFTER

Four-color inserts, showing Greenwell Goetz Architects's projects, are selected according to a client's needs and bound into a binder or stuffed into pocket folders.

into a pocket folder along with project sheets. A midlevel sales kit includes the same materials as the pocket folder, but they're bound together between two covers printed on the same stock as the pocket folders. The third tier takes the system a step further by including a vinyl outer cover that is eyelet grommeted to the paper cover beneath. All of the brochures are bound in-house by Greenwell Goetz with a Rolla-bind system. Having its own binding capability allows the company to customize each client package according to its needs.

All three packages are sent by courier to prospective clients in a zip-lock bubble packet called a "bubbleope." "That's an item I got from a shipping supply company. It works better than a standard envelope," says Grafik Marketing Communications designer Jonathan Amen, noting that the bubbleope provides a moisture barrier as well as protection against blows.

Pocket Folder Gets Custom Touch

Firm: Designation Inc.

Art directors: Mike Quon, Ed Baum

Designers: Mike Quon, E. Kuo

Client: Chase Manhattan Bank/bank

Problem: Client wanted pocket folders that were specific to its services.

When Chase Manhattan's representatives contacted Mike Quon of Designation Inc. about a pocket folder redesign, the bank wanted pocket folders that would be more focused in addressing the specific needs of its corporate banking customers. The generic pocket folder with the bank's logo on its cover that the bank was currently using had provided flexibility—allowing for a mix of a variety of inserts to address each prospective customer's needs—but the cover itself didn't communicate any of the bank's services or their benefits.

Quon and his firm developed a series of new pocket folders that address the concerns of recipients through their cover graphics. With each, the Chase Manhattan logo takes a backseat to benefits-oriented copy and related graphics. All are related with a consistent graphic treatment that places in the same location the Chase logo, the bank name and the banking service being addressed.

The Chase Trader folder focuses on converting foreign currency to liquid funds. To address the global nature of businesses interested in this service, Quon and his design team created for the cover a graphic image of a globe that displays symbols for different foreign currencies. Quon didn't invest in a library of foreign language fonts to produce the visuals for this image. "Once we found out what the icons looked like, we drew them," he relates.

A folder containing information on Chase Manhattan's offering of computerized transactions features a cover graphic of a computer surrounded by business-related icons. "Because it was dry material, the cover visuals were used to set a trend for the look of the interior," says Quon. In this instance, the Designation designers developed a pattern for the folder's interior that echoes the cover treatment.

In addition to interior graphics, the pocket folders also feature die-cut pockets that coordinate with the cover graphics. "We grew it into something more spectacular. The budget was very high," admits Quon. In spite of a huge budget, Quon treated the folder's color palette with businesslike restraint, using cool metallic neutrals and warmer colors as graphic accents for each pocket folder's title.

Chase Manhattan's original pocket folder was nicely designed, but its generic quality failed to address specific services.

The new pocket folders immediately identify the needs of Chase Manhattan's customers with service-oriented cover copy and related graphics.

Sales Kit Gets Coordinated

Firm: Bernhardt Fudyma Design Group, Inc.

Art directors: Craig Bernhardt, Ignacio Rodriguez

Designers: Ignacio Rodriguez, Iris Brown, Kelly Holohan

Client: CommVault Systems/software manufacturer

Problem: Client wanted to upgrade its identity.

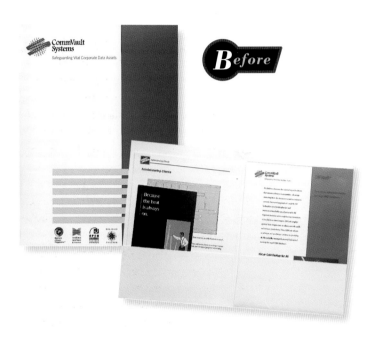

CommVault's former sales kit didn't project a consistent image. Its various components felt as though they had been thrown together rather than planned as a part of a cohesive system.

CommVault Systems's sales kit, a pocket folder containing several promotional brochures and interchangeable fact sheets, needed improvement when its executives contacted Bernhardt Fudyma Design Group, Inc. about a redesign. The folder and its contents failed to project a unified and consistent image that firmly positioned the company as a manufacturer of networking and protected data management software. "They wanted to create a graphic system that could tie their marketing materials together," says Bernhardt Fudyma principal Craig Bernhardt.

The firm's answer was to start with the development of a grid of one-inch (2.5cm) squares, which is used as a background treatment on the pocket folder and all of its inserts. In addition to unifying the sales kit's various components, the grid also served as a means of determining where graphic elements and text would fall on each of the sales kit pieces.

Bernhardt Fudyma incorporated the CommVault logo into the design of the pocket folder and its components by enclosing it within a black square in the upper right corner of each piece's background grid. The consistent treatment gave more substance to the logo and helped to further unify the various components of the sales kit. Bernhardt Fudyma changed the CommVault typeface to Rotis, a similar but more contemporary version of what CommVault uses for its logotype. Rotis is also used in the headings that appear in CommVault's sales literature.

In addition to unifying the sales kit components with consistent typography and logo treatment, a palette of photos that conform to the grid layout were used in a configuration that counterplays small photos against large. "We went through a range of stock sources to find pictures that were visual metaphors for security, safety and networking, even though they may not have anything to do with high-tech computing," says Bernhardt. To counterbalance these conceptual images, Bernhardt Fudyma interjected the human element with head shots of individuals cropped to a one-inch (2.5cm) square. "There are always people involved," says Bernhardt.

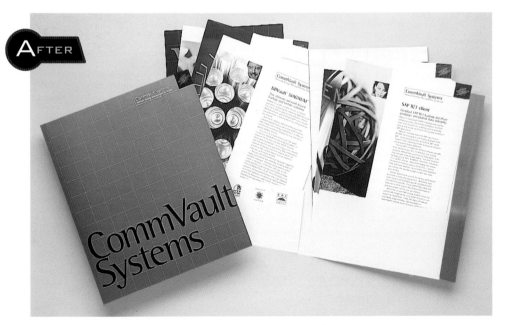

The new sales kit uses a graphlike grid to unify its various components. Consistent typography, logo and image treatment also helps to convey a well-coordinated look.

Move From Slick to Natural Repositions Cigar Company

Firm: Hornall Anderson Design Works, Inc.

Art directors: Jack Anderson, Larry Anderson

Designers: Larry Anderson, Mary Hermes, Mike Calkins, Mike Brugman

Client: U.S. Cigar/cigar distributor

Problem: Client needed to project a different image to stand out against its competition.

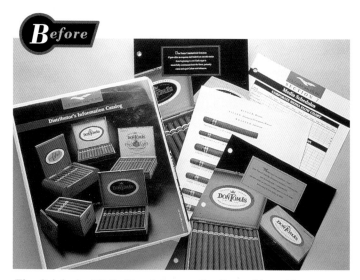

The slick look of U.S. Cigar's former distributorship guide was so similar to other cigar distributors' promotional materials, it failed to help the new company stand out among its competition.

After promoting its products with slick, four-color marketing materials, U.S. Cigar felt a change was in order when it contacted Hornall Anderson Design Works, Inc. "Because they're relatively new in the cigar industry, they wanted to establish a strong presence while setting a higher standard for how collateral materials are created," says designer Larry Anderson. "A lot of the material out there is very slick. We thought it would be best to get back to the roots of cigar manufacturing."

This change of face is projected in U.S. Cigar's distributorship guide. The binder, which is used as a marketing tool by U.S. Cigar's sales force, is made from natural and recycled materials. "Practically everything in it is literally from the earth," says Anderson. Its cover evokes a handcrafted look through its use of a dark, tactile paper made from beer mash. The new U.S. Cigar logo, which Hornall Anderson Design Works, Inc. also designed, is foil-stamped in black on the front of the binder, while a tobacco leaf is stamped on its spine.

Interchangeable product inserts within the binder depict the different characteristics of each cigar through illustrations, color and typography that merge to form a picture of a typical procurer of each distinct brand. "It's about the personalities associated with the cigars," says Anderson. Each insert also includes a hint of nostalgia, such as retro patterns from cigar boxes, vintage ledger sheets and handwriting from turn-of-the-century journals. For a rich, textural look, some of the inserts are printed on Savannah, a paper manufactured in Havana and made from tobacco.

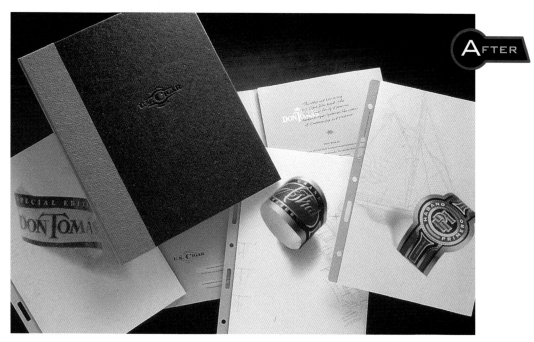

U.S. Cigar's new image is rich and natural. The distributorship guide's cover sports a new logo, configured to resemble a cigar band, while its inserts exude romance and adventure.

One Brochure Becomes Three

Firm: Corey McPherson Nash

Creative director: Michael McPherson

Designers: Richard Rose, Christian Schwartz

Client: Buckingham Browne & Nichols School/private school

Problem: A single brochure needed to be broken down into three brochures.

Buckingham Browne & Nichols (BB&N) is a private school that serves children from kindergarten through twelfth grade. With three campuses in the Cambridge, Massachusetts, area, the school's officials felt a single brochure would help unite the school visually when they contacted Corey McPherson Nash about a redesign.

However, Michael McPherson, the brochure's creative director, and Richard Rose, the designer, felt differently. "It was important to graphically separate the Lower School materials from the Middle and Upper School information because many students enter BB&N at the Middle level. Older students would be turned off by the inclusion of Lower School materials," says McPherson. "It just wouldn't be 'cool' to have a brochure marketed to this group with photos of six-year-olds in it."

The Corey McPherson Nash designers were able to convince the school's officials that creating more than one brochure would help its recruiting efforts. "Then the question was, 'How do we preserve the one-school feeling?'" says McPherson. The problem was resolved when the designers decided to feature a Charles River footbridge, close to the school, on the cover of both brochures so that when the two brochures are joined together, both sides of the bridge connect. The bridge serves as a metaphor for the journey BB&N students make from school to school, and it also helps to establish the school's Cambridge location. To enliven the quiet bridge scene, student art and school icons were added to the bottom of each cover.

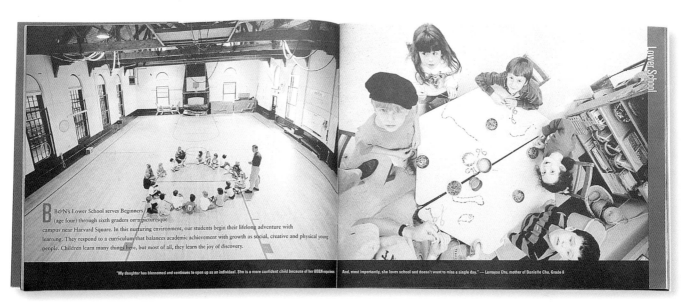

Buckingham Browne & Nichols School's former brochure was nicely designed, but Corey McPherson Nash found a way to make it a more effective recruitment tool.

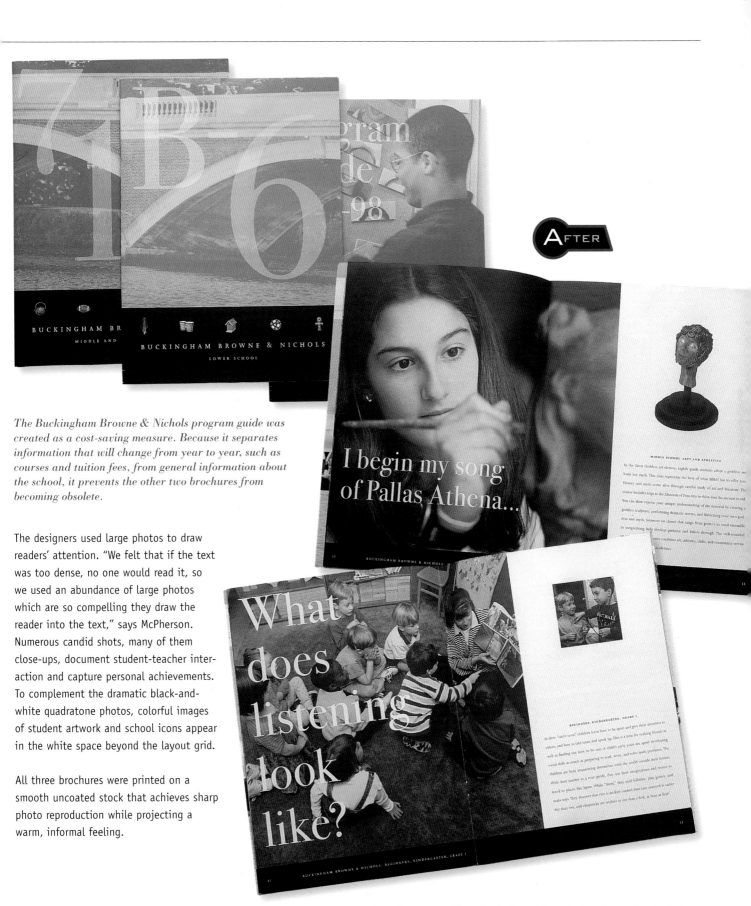

The Buckingham Browne & Nichols program guide was created as a cost-saving measure. Because it separates information that will change from year to year, such as courses and tuition fees, from general information about the school, it prevents the other two brochures from becoming obsolete.

The designers used large photos to draw readers' attention. "We felt that if the text was too dense, no one would read it, so we used an abundance of large photos which are so compelling they draw the reader into the text," says McPherson. Numerous candid shots, many of them close-ups, document student-teacher inter-action and capture personal achievements. To complement the dramatic black-and-white quadratone photos, colorful images of student artwork and school icons appear in the white space beyond the layout grid.

All three brochures were printed on a smooth uncoated stock that achieves sharp photo reproduction while projecting a warm, informal feeling.

To prevent adolescents from "turning off" on the look and feel of a brochure that includes information for elementary school-aged children, Corey McPherson Nash's design solution resulted in two brochures: one for BB&N's Middle and Upper Schools and the other for its Lower School.

Growing Investment Firm Polishes Its Image

Firm: Designation Inc.

Art directors: Mike Quon, Elliot Berd

Designers: Mike Quon, E. Kuo

Client: GeoCapital/investment firm

Problem: Client wanted to upgrade to a more professional image.

GeoCapital, a New York City-based investment firm, had reached a point where its success warranted a more upscale image than its promotional brochure projected. At that point in time, the company was working with nothing but a brochure produced at a quick-print shop. "We made them realize that a company that was going to grow itself needed various printed elements. The bound book met just part of those requirements," says Mike Quon, of Designation Inc., the design firm that redesigned GeoCapital's capabilities brochure as well as their new identity materials.

Because smart investing results in capital growth, Quon led his firm in the development of several growth-related image concepts including a tree. However, the concept his client responded most positively to was based on a chambered nautilus. "It's one of those things that shows multiplication," says Quon, referring to the nautilus's mathematically perfect proportions. The nautilus's spiral growth is translated into a graphic element that appears on the brochure cover and pocket folder. A paragraph on the inside front cover of the brochure explains this natural phenomenon and ties it in with GeoCapital's investment strategy.

Quon wanted to give his client a graphic palette that worked on all of its promotional and identity materials. In addition to the nautilus spiral, the design firm developed a logotype that contrasts *Geo* and *Capital* with different typographic treatments. The logotype includes an abstracted arrow that adds emphasis to *Geo* and helps to unify both typographic components.

GeoCapital's former brochure exhibited a dated logo on its cover. Its plastic comb binding added to the brochure's lack of sophistication.

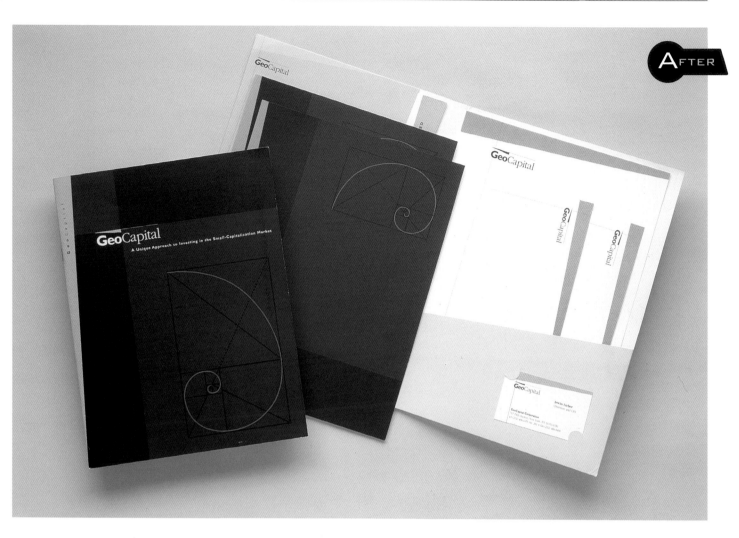

GeoCapital's new identity is carried into its new letterhead and business card.

In the development of the new identity, Quon kept the dark blue that had been used on GeoCapital's former brochure. "I think it's a wise thing to do that so there's a connection to their corporate culture," says Quon. "The blue is also a very serious business color, and the green is the obvious flip side of financial services."

Brochures Become Easier Read While Projecting Stronger Identity

Firm: Smullen Design Inc.

Art director: Maureen Smullen

Designers: Maureen Smullen, Brett Chambers, Jim Brazeale

Client: West Hollywood Convention & Visitors Bureau/convention and visitors bureau

Problem: Former brochures failed to express city's personality.

When Maureen Smullen of Smullen Design Inc. redesigned West Hollywood Convention & Visitors Bureau's identity, her firm also took on the task of redesigning a series of brochures that direct visitors to hotels, restaurants, art galleries and nightspots in the area. Smullen Design Inc. came up with a new set of cover designs that tie-in with the identity materials her firm designed (see pages 56–57) and more effectively convey the sunny, southern California flavor of West Hollywood.

Smullen chose to do illustrations for the brochures' covers rather than photography for several reasons. She wanted to steer away from showing photographs of specific locations, because she was afraid they might date the brochures in a few years. "We were also heading in that direction with the look of the logo," says Smullen, adding that each of the illustration's background shapes was pulled from the rectangles in the *West* of the West Hollywood Convention & Visitors Bureau logo. Smullen created the digital illustrations herself in an illustration program after sketching rough versions and scanning them to use as guides.

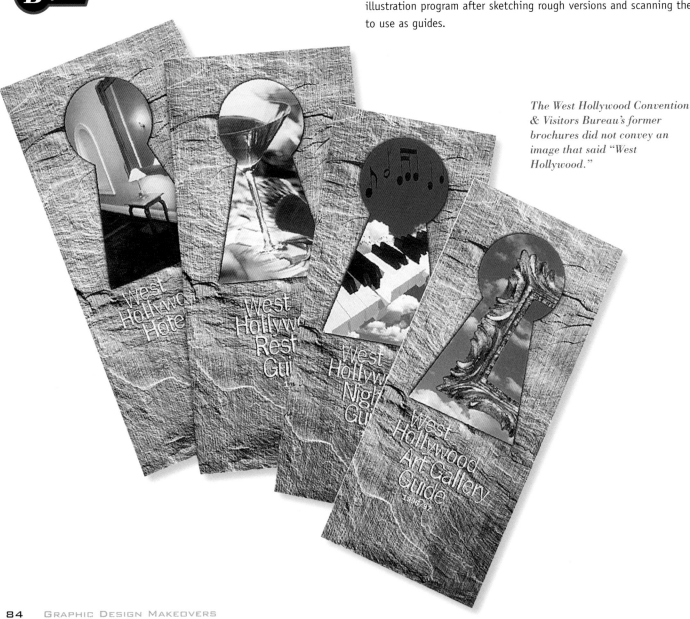

The West Hollywood Convention & Visitors Bureau's former brochures did not convey an image that said "West Hollywood."

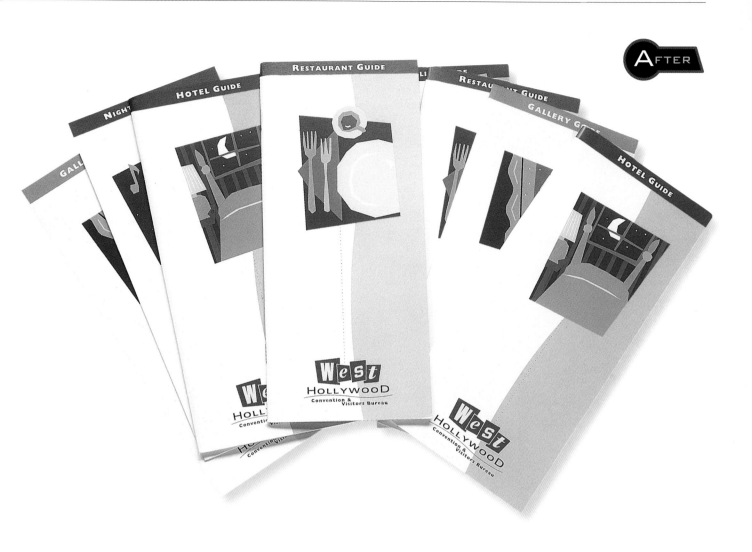

The illustrations are placed in a format that coordinates with West Hollywood Convention & Visitors Bureau's other identity materials—one that incorporates the Convention & Visitors Bureau's logo along with a curvilinear margin of a color from the identity's palette.

To improve readability, Smullen decided to expand the brochures' format from a folded size of 3½" x 8" (8.9cm x 20.3cm) to 4" x 9" inches (10.2cm x 22.9cm). The larger size still fits in a standard business-sized envelope, but allowed Smullen to incorporate more white space in the brochures' layout and text. To tie in with the look of the Convention & Visitors Bureau's other materials, Smullen set the brochure copy in the same typeface used for the *Hollywood* that's part of the Convention & Visitors Bureau's logo.

The new brochures capture the spirit and sunny climate of West Hollywood and coordinate with the look of the other identity materials designed by Smullen Design Inc.

In addition to expanding the brochures' size and making text easier to read, Smullen also improved on other features. For instance, the map of art galleries—positioned vertically on the original brochure—was repositioned horizontally on the redesigned version. To improve visual appeal and readability, Smullen also added color to the map.

Upscale Image Directed at Decision Makers

Firm: Iridium Marketing & Design

Art director: Jean-Luc Denat

Designers: Etienne Bessette, Jean-Luc Denat

Photographer: Headlight Innovative Imagery

Client: Cognos/business intelligence software manufacturer

Problem: Client needed to target a higher level of customers' management.

When Cognos executives contacted Iridium about redesigning its promotional materials, the business intelligence software manufacturer wanted to target Fortune 500 companies. "They realized that with these larger companies the decision to purchase is made by higher level management," says Jean-Luc Denat, Iridium's art director. To Denat and his design team, it soon became obvious that Cognos needed a more upscale look to appeal to executive decision makers and set itself apart from the competition.

Iridium started by working with a new benefits-oriented company slogan developed by Cognos that would appeal more to executives. "Better decisions every day" replaced the tech-oriented "tools that build business" Cognos used previously. The slogan appears on the bottom of each brochure cover within an index tab-shaped area, as well as on product fact sheets. The consistent treatment of the slogan, typography and imagery helps to unify the pocket folder's contents.

Iridium also replaced the four-color illustrations previously used on Cognos's brochures with subtle duotones of executives "in action." "We thought the human element was all important, because the software they produce is designed to help people make better decisions," says Denat of photos of executives in problem-solving situations obtained from stock sources and shot by Headlight Innovative Imagery.

Iridium switched to a more neutral palette, using shimmery gold, silver, copper and other metallic inks for a rich finish and more sophisticated look. The subtle palette also helps to direct attention to the Cognos logo, printed in corporate red.

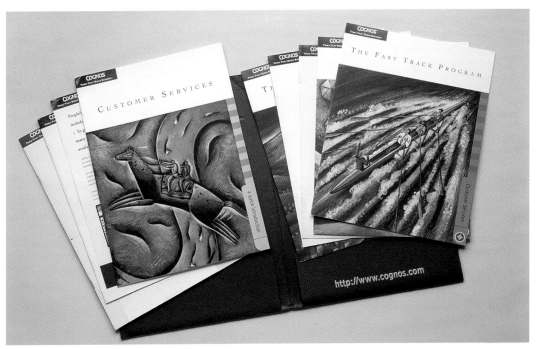

Cognos's former promotional kit appealed more to the technical administrators of its software products.

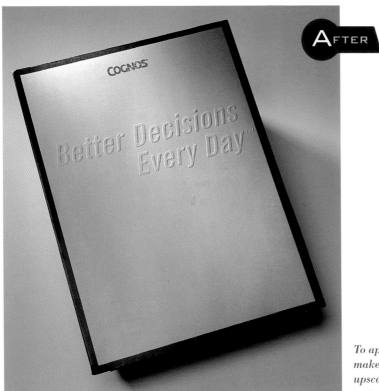

To appeal to executive decision makers, Iridium designed a more upscale look for Cognos's collateral materials and pocket folder.

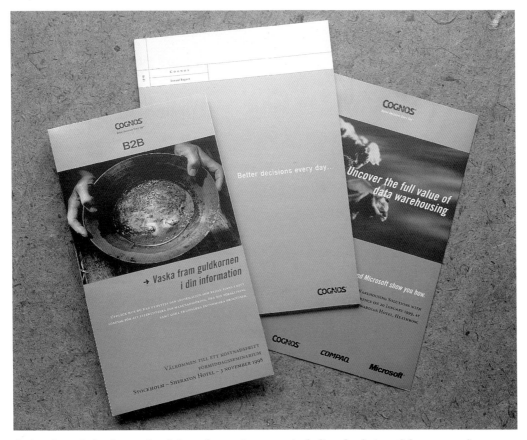

Iridium's work for Cognos has led to other assignments, including the design of the company's annual report and executive seminar invitations. All are printed in the metallic inks that are an important part of Cognos's new look.

Illustrations Upgrade Status of Medical Center Brochure

Firm: Designation Inc.

Art directors: Mike Quon, Steve Phelps

Designers: Mike Quon, K. McAulay

Illustrator: Mike Quon

Client: Catholic Medical Center of Brooklyn & Queens Inc./medical center

Problem: A single brochure needed to be upgraded and broken down into three brochures.

Designer Mike Quon, of New York City-based Designation Inc., had an opportunity to revisit a project he had previously done when he was asked to upgrade an existing brochure for the Catholic Medical Center's (CMC) Residency Program in Medicine's brochure.

Used to recruit medical school graduates needing to fulfill their residency requirements, the brochure was initially designed by Quon in 1996. It contained general information about the program and included a pocket on the inside back cover where inserts addressing more specific information about CMC's three residency programs could be tucked in. Three years later CMC wanted to break the brochure down into three brochures, each of which would address a specific residency program.

The second time around, Quon was able to design the three brochures more to his liking by creating visual interest with illustrations rather than photographs. "A lot of times people like to include photos," says Quon of the original brochure that featured photos shot by CMC staff members. However, the quality of the photos was so poor, Quon had to show them on a very small scale. "In this case, I convinced them it was more beneficial to use illustration because you don't have to worry about whether the individuals in the photo are still there."

Quon created a layout that contrasts a soft, contemporary illustration style with geometric shapes in different colors. He initially rendered the illustrations in pen and ink, then scanned and colorized them in the computer using a combination of Adobe Streamline to outline his scanned art and Adobe Illustrator to color it. The three brochures are unified by their consistent graphic approach and the same cover illustration.

The brochures are mailed to applicants and displayed at conferences and CMC's headquarters. "They spent quite a bit more money," says Quon of CMC's decision to upgrade its original brochure to its current incarnation of three. Although the same number of pages were used (the previous brochure's page count of twelve was divided into three four-page brochures), the new brochures are larger and printed in four colors rather than three.

The Catholic Medical Center's original Residency Program in Medicine brochure created visual interest with photos.

Designation Inc.'s redesign
created three brochures
from one and features
bright, contemporary illus-
trations.

*I wanted ethical
hands-on experience
working with a commu-
nity-based hospital serv-
ing a large urban popu-
lation. CMC was the
perfect fit for me. I'm
getting valuable exposure
to every type of patient
and pathology and expe-
rience second to none.
We get to work with
both service and private
patients and our faculty
and attendings help me
to learn by doing. I like
the depth of teaching and
the caring atmosphere.*

– Melissa Weinstein, DO

Catholic Medical Centers (CMC) is the Brooklyn and Queens campus of
the Albert Einstein College of Medicine. The residency program of the de-
partment of obstetrics and gynecology is a four-year program which places
particular emphasis on primary care. It is administered by the St. John's
Queens Hospital, St. Mary's Hospital of Brooklyn, and Mary Immaculate
Hospital divisions of CMC. Residents successful in completing the pro-
gram are eligible for certification by the American Board of Obstetrics and
Gynecology.

Graduates of CMC's OB/GYN primary care program are trained to be com-
petent and comprehensive primary care providers to women, and, upon
completion of their training program, will be qualified to perform the fol-
lowing procedures:

Surgery for urinary incontinence
Abdominal and vaginal hysterectomies
Adnexal surgery
Diagnostic and operative laparoscopy
Vaginal deliveries
Forceps and vacuum deliveries
Vaginal breech deliveries
Caesarian deliveries
Vaginal births after Cesarean delivery
Amniocentesis
Ultrasonography
Neonatal intubations

Residents will also be trained to manage:

Gynecologic oncology cases
Bleeding during pregnancy
Multifetal pregnancies
Medically complicated pregnancies
Uncomplicated pregnancies
Infertility and reproductive endocrinology cases

Currently, Catholic Medical Centers' OB/GYN residency program has 18
residents with six in the first year. Two of the six positions in the first year
are preliminary and four are categorical. There are four residents in the pro-
gram per year for years two, three and four. The teaching staff is comprised
of both full-time faculty members and voluntary private practitioners.

*We work with a
very good mix of popu-
lations and because our
program is small, I can
concentrate more on
patients. Although I
intend to work in mater-
nal-fetal medicine and
teach in an academic
medical center in the
future, my clinical expe-
rience at CMC has been
so diverse as to prepare
me for anything.*

– Lester F. Bussey, MD

3

BOOKS AND MAGAZINES

BO

RTISTS • WRITERS • ACTORS

Bomb Downsizes to a More Reader- and Advertiser-Friendly Design

Firm: Platinum Design, Inc.

Creative director: Vickie Peslak

Art director: Kathleen Phelps

Designers: Mike Joyce, Kelly Hogg

Client: *Bomb*/arts and literary publication

Problem: Client wanted a format and design that would appeal more to advertisers.

Bomb, New York City's nonprofit arts and literary magazine, has a loyal following and a reputation for recognizing brilliant new talent that's spanned eighteen years of publication. However, the magazine's publisher and editorial staff felt it was time to make some changes when they contacted Platinum Design, Inc. about a redesign. "They felt it would be easier to attract advertisers if they had a more traditional size," says Platinum Design, Inc. principal Vickie Peslak. Switching from *Bomb*'s tabloid format to something smaller prompted a reevaluation of the magazine's design as well.

Platinum Design Inc.'s design team and *Bomb*'s editorial and production staff first met with the printer to determine what size would be best. They agreed that an 8⅞" x 10⅞" (22.5cm x 27.6cm) format would work for advertisers and be cost efficient to produce, but unconventional enough to still support *Bomb*'s reputation for bucking tradition.

From there, the designers set some standards for the magazine's overall look. "We felt it was very text heavy. It needed the relief of more art and white space," says Peslak. The designers also thought the magazine needed a stronger identity. "We purposely limited the number of typefaces. Previously their typography had been all over the place," says designer Kelly Hogg. The design team decided to use Bell Gothic for *Bomb*'s main body text and a handful of classic fonts, including Grotesk and Clarendon, for headlines. In addition to establishing a cohesive image, the consistent typographic treatment helps to unify the magazine and make it more reader friendly.

Bomb's former text-heavy layout made it hard to read. Its tabloid format was a challenge for advertisers accustomed to producing ads to fit a traditional 8½" x 11" (21.6cm x 27.9cm) format.

"First Proof," *Bomb*'s literary supplement—which was difficult to locate in the former design—was given its own logo and a stronger presence in Platinum Design Inc.'s redesign. "We chose to print it on a different stock," says Peslak. Because *Bomb*'s editorial section is limited to two colors, the design team chose a second color for "First Proof" that complements but contrasts with the color for the rest of the magazine.

"We felt strongly about keeping the logo," says Peslak, who wanted to preserve *Bomb*'s logo's high recognition level. They retained its prominence on the magazine's cover, but departed from former covers by silhouetting and cropping cover subjects in unusual ways.

Bomb was redesigned to work on a slightly smaller scale and be more reader friendly. Platinum Design Inc.'s new design also establishes a stronger, more unique identity for Bomb.

Classical Elegance Suits Magazine for Flutists

Firm: Tom Varisco Designs

Art director: Tom Varisco

Designers: Tom Varisco, Jennifer Kahn

Photographer: Michael Terranova

Client: *The Flutist Quarterly*/periodical for National Flute Association members

Problem: Magazine's former covers weren't appropriate to the subject matter.

Before its redesign, The Flutist Quarterly's covers ran full bleed and often featured illustration. The covers projected an image that fell short of the elegance associated with flute playing.

The Flutist Quarterly is a membership benefit for flutists who belong to the National Flute Association. The magazine goes out to over 65,000 members all over the country, bringing them association news, conference information and other items of professional interest. The magazine had been produced entirely in-house by its editor when designer Tom Varisco was hired to give its covers a more contemporary look.

Varisco started by developing a new logo for *The Flutist Quarterly*. He took an *f* set in Garamond and modified it with an elongated cross stroke to create an *f* that resembles a forte symbol. He set the remainder of the logo in Mrs. Eaves Bold, which was used in a lighter weight for the other typographical elements on the cover's masthead.

The cover's layout, with its ample white space, projects a clean, pristine look. The large white border on the left also offered Varisco the opportunity to create headline type that overprints the cover's photo and its border in intriguing ways.

Instead of using illustration as past covers had, Varisco decided that a concept-driven studio photo would best serve *The Flutist Quarterly*'s covers. His first cover photo as art director, for the Spring 1997 issue, features a flute and sheet music in a floral setting. The cover headline was written by assistant Jennifer Kahn. "That was a hard one to do," says Varisco, explaining that because the photo's "floating" flute was created without computer manipulation by photographer Michael Terranova, it required careful positioning with hidden clamps. The trouble was well worth it. *The Flutist Quarterly*'s editor was very pleased with the results. "After that, they really got into concept-driven covers," says Varisco, adding that they've become as much a part of *The Flutist Quarterly*'s image as its logo and cover layout have.

For a convention issue, Varisco pulled a quote from the association's convention materials to use as a headline. A road map, a peach and the convention's date and location, jotted as notes, serve as a reminder of this important annual event to members.

Referring to the classical, pristine look of The Flutist Quarterly cover's typography and layout, Varisco says, "Flute playing is elegant, so we tried to make the cover look like a flute."

Varisco maintains the same layout from one cover to the next, but varies the color used for the logo and comes up with a photograph suitable to the issue's theme. A decorative capital A adds a vintage touch to a cover addressing the association's history. The cover photo is a set-up shot of a flute, old photos supplied by The Flutist Quarterly's editor and an old photo album of Varisco's. The old photos used for the photo shoot were actually digital prints of scans of black-and-white originals, which were colorized with a sepia tint in a photo-editing program.

Labor Union Magazine Gets First-Class Treatment

Firm: Bernhardt Fudyma Design Group, Inc.

Art directors: Craig Bernhardt, Ignacio Rodriguez

Designer: Ignacio Rodriguez

Client: *The Mason Tender*/labor union magazine

Problem: Client wanted to upgrade its image.

The Mason Tender is a quarterly magazine published by the Mason Tenders District Council, a labor union for mason tenders in greater New York City. The magazine features items of importance to its union members, but is also directed at others involved in New York City's construction industry, including architects, real estate investors, property owners and others in a position to hire union members. "It's an all-purpose communications vehicle," explains Craig Bernhardt, of Bernhardt Fudyma Design Group, Inc., the design firm behind *The Mason Tender*'s redesign. It was Bernhardt Fudyma's job to upgrade the design of this important publication to a more professional level.

When Bernhardt Fudyma got involved in the redesign, they discovered that *The Mason Tender*'s publisher was able to offer a more generous production budget for the new magazine than what had previously been allotted. "We were told that they wanted to go 'first class,'" says Bernhardt. The designers were given a variety of professional photographs to work with and four color throughout the publication.

Bernhardt Fudyma started by designing a logo for the magazine's cover. "It was just words before," says Bernhardt. The logo, based on Helvetica Ultra Compressed, sets the tone for the magazine's interior graphics, which feature heavy rules in the same colors and department headings set in Helvetica Ultra Compressed.

Bernhardt and his design team wanted *The Mason Tender*'s cover to focus on the workers rather than on the buildings on which they've worked. Interior photos were also applied liberally to add human interest and spice up editorials. To clean up photos with cluttered backgrounds, the designers silhouetted images. "It was also another

Joseph and Anthony Alizio.

"I Enjoy Being A Bricklayer"

The scenario is simple but stirring. A young man of 18 emigrates from his native Italy to the United States right after World War One. Using the stone mason skills learned in his native land, he builds a life for himself and his family in his adopted homeland. He marries. He starts his own brick business. His wife has twin boys.

The business progresses, from masonry work on one and two family homes to six-story buildings. The boys are sent to a strict Catholic boarding school. After that, they take pre-law courses at an excellent college, and three years later, they enter a metropolitan area law school.

The twins — now young men — are in their final semester of law school. Spring is in the air. It is a fair day in May. Suddenly, a telephone call! Their beloved father is dead of a massive coronary attack — his first and only coronary. He is gone at the age of 59, months short of his 60th birthday.

All plans change now as the twins jointly decide, they will leave law school and run the father's brick business. Then the

Selective Service intervenes and wants to draft both of them.

Pleading hardship, the young men offer several sound reasons not to be drafted, so the Army compromises.

"You two have to make a decision and you've got five minutes to do it. One of you can stay home and run your father's business. The other of you must serve in the Army."

The decision is made by the flip of a coin.

This is no mid-day melodrama, but the true story of A-One Bricklaying and of the brothers Alizio, Joseph and Antony. (Joseph, incidentally, won the coin toss. Anthony served two years in the US Army.)

From a one man operation, founded by Peter Alizio in the 1920's to do brickwork on renovation jobs and one-family homes, the company today handles the brickwork for anything from 5-story to 20-story —and higher— buildings. A-One also has participated as builder/owner on over 1800 apartments throughout Queens. In addition the firm is responsible for the masonry

tragedy struck.

Their father indeed would be proud of them, for they have built a company with a fine reputation for craftsmanship. One reason for this has been the

> *"I enjoy being a bricklayer. I especially appreciate the people who work with us and for us. I find them hard workers, intelligent, experienced, dedicated."*

role of the individual bricklayers and mason tenders. Several mason tenders have been with A-One for many years...men such as Benjamin Blount, over 30 years; John Samuel West, Peter West, Anthony DeMasi, Al Anderson, Miguel Mendez, and Thomas Morelli, over 15 years; James Godwin, over 20 years. A relative "newcomer" is labor foreman Alex Krūll, now in his fifth year with A-One.

The Alizios have a love for what they do and a genuine respect for those with whom they work. Says Joe: "I enjoy being a bricklayer. I especially

craftsmanship on the Parker Meridian Hotel, 57th Street between Sixth and Seventh Avenues, Manhattan, and on scores of other structures, among them a 36-story high rise at 86th Street and York Avenue (for Long Island Properties), two 24-story buildings in the Rockaways (for Gotham Construction Co.), and a 20-story building at 34th Street and Lexington Avenue (for Donald Zucker). The Lexington Avenue job was the first high-rise project A-One handled.

Peter Alizio married the former Jennie Giacone in 1933. She, too, had been born in Italy and emigrated here. On January 28, 1937, at Mother Cabrini Hospital in Manhattan, the twins were born. As they grew up, their father took a temporary leave from his brick business to help the war effort. He worked at the old Wheeler Shipyard in Whitestone, Queens. After the war he was back, handling many one and two-story homes all over Queens. The boys attended Salesian High School, then Virginia Wesleyan, then New York Law School, where they were when

appreciate the people who work with us and for us. I find them to be hard workers, experienced, dedicated."

"I'd even say this: if I had to be a mason contractor forced to employ non-union personnel, I would prefer leaving the business and finding something else to do."

Tony adds: "The mason tenders and the bricklayers are the hardest working trades in the building industry. They are the craftsmen, the tradesmen. Most of them are good family men with good attitudes."

And how about the future? The Alizios are, again, characteristically outspoken. Says Joe: "I am bullish about the future. It may not come with this Cowboy administration, but I think that with future administrations you

will see a lot of housing work in New York City."

According to Tony Alizio, "We are lucky enough to have work now, but no one has a crystal ball. My feeling is that unless we have a new Administration in Washington, one which will be more sensitive to housing programs, this area will be in trouble. Housing in this area is out of the reach of the blue collar working family, and it simply must be subsidized."

The positive note is that when the multi-family housing picture does turn around, the Alizios will be in there with a double-barrelled effort building a better future, in brick. □

Peggy Husath, Dorothy Nuerge, and Diana Bernstein.

Joseph Alizio and A-One's Estimator, Robert Curcio.

The Mason Tender's former covers failed to engage readers because they featured buildings instead of people. A newsletter-style layout and a black-and-white interior gave the magazine a low-budget, unsophisticated look.

way to create visual interest, rather than using all square or rectangular shots," says Bernhardt.

Liberal use of white space and setting body text in Baskerville added refinement to the magazine's interior and made it more reader friendly. Bernhardt Fudyma also departed from *The Mason Tender*'s former practice of setting text in justified columns in favor of a more casual rag right—a format that further improved legibility and allowed them to more easily wrap text around silhouetted photos.

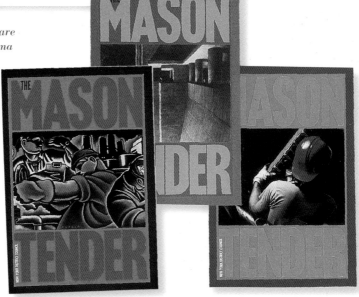

The new cover engages by focusing on the workers. Interior layouts feature a liberal application of color, photography and clearly defined department heads.

Although many of the photos featured in The Mason Tender *are shot on-site by professional photographers, Bernhardt Fudyma Design Group, Inc. designers often deleted distracting background elements by silhouetting the photo's subjects. The technique created an opportunity for wrapping text in interesting ways and became a signature element of the publication's interior layout.*

An alternative cover design Bernhardt Fudyma Design Group, Inc. explored featured a more prominent logo treatment.

Social Symbol Suits Book Cover

Firm: Dalkey Archive Press

Art director: Todd Michael Bushman

Designer: Todd Michael Bushman

Client: Dalkey Archive Press/restorer of out-of-print books

Problem: A contemporary look was needed for novels originally published in the 1980s.

*C*igarettes, originally published in 1987, is an extremely complex novel about sixteen characters involved in fourteen pairs of relationships from the 1930s through the 1960s. "I wanted to get away from the complexity of the book and make it simple so readers didn't have a complicated cover to deal with," says Todd Michael Bushman, the designer of *Cigarettes*'s new cover.

To communicate the concept of people engaged in social interaction, Bushman bypassed the obvious choice of portraying a group of people in a social setting. Instead, he decided to use a cup of coffee as the cover's central image. "It's what upper-class people usually do when they're sitting around talking," he explains. Bushman took a stock photo and isolated the cup and saucer from its background in a photo-editing program. He recolored the image and merged it with a scan of a laser print of the same image "to give it a grainy look," Bushman relates.

Bushman built the border in a drawing program, using a symbol from a dingbat font for the corners. Amazone, a vintage script, was used for the book's title. To complement rather than compete with the scripted title and ornate border, author Harry Mathews's byline was set in Unitas, a sans serif typeface. To match the grainy look of the coffee cup, Bushman scanned a laser print of the border and cover type and used them for the final cover art.

Although Bushman explored a color background for the cover, he opted for pure white. "I wanted it to be very simple and clean," he explains. "I thought adding a color to the background would make it more complex and bring something into it that I didn't want."

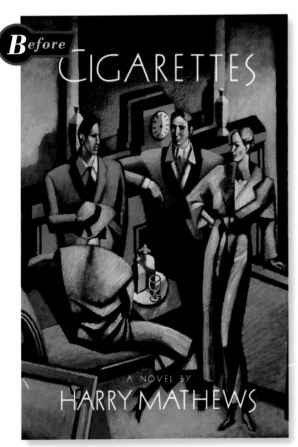

Cigarettes's original cover gets its social theme across with a painting of elegantly garbed individuals in a social situation.

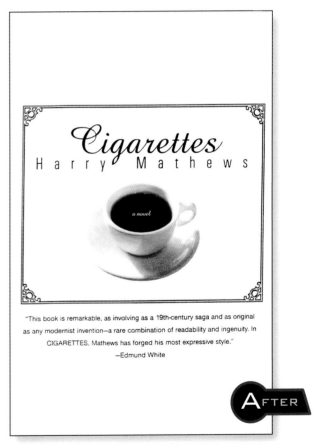

The redesigned cover is more subtle in its portrayal of a social setting. Instead of showing a gathering of people, it uses a cup of coffee as a symbol.

Publisher Brings Outdated Literature Into the Twenty-First Century

Firm: Dalkey Archive Press

Art director: Todd Michael Bushman

Designer: Todd Michael Bushman

Client: Dalkey Archive Press/restorer of out-of-print books

Problem: A contemporary look was needed for novels originally published in the 1980s.

Bringing out-of-print books into the next century is the mission of Dalkey Archive Press, a nonprofit organization based on the campus of Illinois State University. "We look for major works and restore the books so that people have access to them," says designer/production manager Todd Michael Bushman, who designs covers for the book restorations.

A recent restoration project required Bushman to interpret the theme of political oppression in a more contemporary manner. *The Polish Complex*, a novel by Tadeusz Konwicki originally published in 1977, is about the dictatorial government and its oppressive policies that existed in Poland from the late nineteenth century through most of the twentieth century.

To express this, Bushman chose to depict an individual with his eyes and mouth covered. "People didn't have their own vision of the future. The government directed it. They also didn't want them to speak their mind. That's where the hand comes in," says Bushman.

Bushman used a stock image for the face and scanned his own hand by placing it on a flatbed scanner. Both images were converted to grayscale in Adobe Photoshop, where the halftone filter was applied to give them an exaggerated dot pattern typical of newspapers. The filter application also helped to make both images appear more consistent.

The black-and-white image of the face and hand stands out in stark contrast against a patterned background created from two shades of red. "I wanted a harsh color," says Bushman of the cover's background. "I also used red on the letter *I* in *Polish* to represent 'I' or 'me.'" Bushman created the patterned background by multiplying a modified symbol from a dingbat font. It appears in its original form between the book's title and byline, set in Electra.

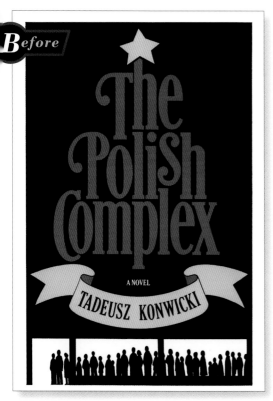

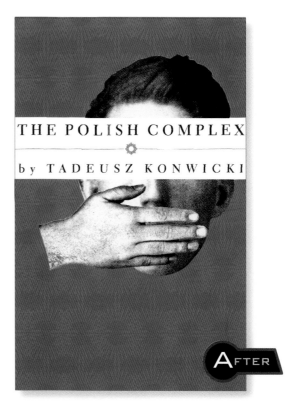

The Polish Complex's original cover projects a design sensibility that was popular in the 1980s. Although it may have been a trend-setting design back then, it looks dated by today's design standards.

Like the original cover, the new design expresses the book's theme of political oppression in a subtle manner, but classical typography and unusual imagery help it fit into a more contemporary venue.

Medical School Alumni Magazine Comes of Age

Firm: Tom Varisco Designs

Art director: Tom Varisco

Designers: Tom Varisco, Jan Bertman, Robb Harskamp

Photographer: Jackson Hill

Illustrator: Mark Andresen

Client: *Tulane Medicine*/Tulane University School of Medicine's alumni magazine

Problem: Client wanted a more impactful and contemporary look.

Designer Tom Varisco was somewhat familiar with Tulane University, having helped to redesign *Tulanian*, Tulane's alumni magazine. But when he got involved in the redesign of *Tulane Medicine*, a magazine for alumni of Tulane University's medical school, he felt the magazine should have a unique identity totally unrelated to *Tulanian*. His meeting with its editor confirmed that the magazine needed a look that suited its editorial content.

With this in mind, Varisco developed a cover design for *Tulane Medicine* that would set it apart from other university publications. "Instead of doing a white cover, we went with something completely different," says Varisco, who started with a full-bleed treatment for photos and illustrations. From there he turned *medicine* on its side and bordered it with a strong color palette that varies from issue to issue. *Medicine* always runs in black, and within the ascender of its lowercase *d*, *Tulane* is reversed to white. Varisco connects this with the magazine's theme by treating the theme feature line the same and reversing it. The all-white typographical treatment draws attention to itself as one of few areas on the cover where there is no color.

Varisco's design for the table of contents repeats the theme established with the cover. Because each issue contains two features, Varisco had to work many visuals into the contents page to give it substance. In lieu of a logo at the top of the page, Varisco designed an icon with the letter *C* that repeats the graphic treatment used on the cover. Department heads, which are given a similar treatment, help to unify the publication.

Tulane Medicine's previous look failed to register the kind of visual impact its editor wanted to achieve.

Tulane Medicine's *bold logo and new cover treatment are more colorful and attention grabbing. The magazine's table of contents benefits from additional photos and an exploded view of an image from the feature section.*

Similar images and consistent use of Helvetica as a display font provide a visual connection between Tulane Medicine's *covers and its feature section and help to unify the magazine. In this instance, two illustrations by Mark Andresen were cropped in different ways so they could be used on the cover, table of contents and on two spreads of an article.*

Business Magazine Strengthens Its High-Tech Industry Profile

Firm: Roger Black Inc.

Art director: Roger Black

Designer: Roger Black

Client: *Red Herring*/business magazine

Problem: Magazine needed a stronger image and improved readability.

When *Red Herring*'s editors decided a redesign was in order, the magazine had enjoyed five years of success as a key resource for high-tech industry business leaders and investors. "It's highly regarded in its target market—the high-end Silicon Valley venture capital crowd," says Roger Black, principal of Roger Black Inc., the design firm behind *Red Herring*'s new design. Black, whose firm is well known for redesigning some of the nation's most popular magazines, was hired by *Red Herring* to strengthen the magazine's image and readability.

Black and his design team first engaged his client in a thorough assessment of the magazine's content and organization. "If you do a redesign without changing and improving the content, it's sending out the wrong signal—saying 'It's different' when it's not," notes Black. Before Black got involved, the magazine's content was broken down into a feature section surrounded by departments, news, reviews and other short articles. Black helped *Red Herring*'s editors devise a better means of structuring the editorial in the front and back of the magazine that reorganizes information so it's easier to find. "Then we did some very careful labeling, where we set up color bars that run at the top of the pages," says Black. Four different-colored bars mark the four sections that constitute the magazine, making it easier for readers to find each section.

Black says that in order to compete with other media, a magazine needs to have a distinct personality. "I've consistently tried to sharpen magazine design to be bolder and more consistent with fewer typefaces, a more restricted color palette and more obvious illustration and photography," he explains. With *Red Herring*, Black and his team devised a vivid illustration style using Adobe Photoshop manipulation. "There's a 'techy' expressionism going on," says Black, "but very quiet typography."

To strengthen the well-established *Red Herring* logo and give it more flexibility, Black removed *The* and the slogan, which now appears below the logo on the magazine's cover. "The little words would've been lost in conference programs and on name badges," he explains.

Roger Black Inc. streamlined Red Herring's existing logo, removing and repositioning the small type to preserve and strengthen its recognition value. The changes allow the logo to appear on a larger scale on the cover.

Departments are separated from features and other magazine sections by different-colored bands at the top of each page. Eye-catching Adobe Photoshop-manipulated photographs and illustrations, used consistently throughout the magazine, add to Red Herring's distinctive, high-tech image.

The redesigned table of contents reflects Red Herring's reorganization. Easy-to-read type, set in High Tower, Caslon Egyptian and Futura, and the absence of background imagery make information easy to find.

College Textbook Sheds Academic Image

Firm: South-Western Thomson Publishing Group

Art director: Jennifer Mayhall

Designer: Michael Stratton

Client: South-Western College Publishing/textbook publisher

Problem: Textbook needed to project a more reader-friendly, contemporary look.

An update of *Principles of Economics*, a college textbook first published in 1996, offered an opportunity to make the book more appealing and user friendly for college students. As publishers of college textbooks, the design team at South-Western Thomson Publishing Group was in a good position to know what would work. "I think a lot of people think that textbook design is staid and strict, but it seems like, more and more, it's loosening up," says designer Mike Stratton.

Stratton and the other designers started with the premise that a magazine look and feel would add instant appeal to the book. They added part openers to the book's layout, where type is run vertically and layered over photos, to create a look that's more like a magazine than a textbook.

To support the book's editorial feel, lots of photos with youth appeal were chosen from stock agencies to add color and visual interest. Photographs of the author interacting with students were also interspersed throughout the book, especially on part openers, to create a personal link between the author and the student reader.

Stratton redesigned charts so they're more reader friendly and created thumbprint-shaped indexes to mark where each chart or exhibit is displayed. Margin notes, directing students to key information, were also redesigned to be more attention grabbing by intruding into the text block.

The book's color palette and cover reflect a more youthful, contemporary look. Stratton's idea for the cover came while he was browsing through stock catalogs looking for an illustration style appropriate to the book's image. He found an illustration by artist Coco Masuda that featured a central figure surrounded by other images. Masuda was contracted to create a cover illustration based on the stock image, but unique to the textbook's needs. "She changed the character and added a few more elements," says Stratton, adding that fish, a farmer and a jet were added to represent topics covered in the book.

As publisher of the first edition of Principles of Economics, *South-Western Publishing was in a good position to know how to improve upon the original.*

The new edition's design incorporates a more contemporary and student-friendly approach.

Charts were made more reader friendly by adding color and differentiating one line from the next. Index tabs resembling thumbprints were added to help direct readers flipping through the book.

Part openers were added to the book for a magazine look and to establish a personal link with the author. To create typographical contrast, Stratton contrasted Casablanca, a condensed sans serif font with a contemporary look, with a serif typeface with exaggerated thick and thin strokes.

Alumni Magazine's New Look Offers Cover Flexibility

Firm: Tom Varisco Designs

Art director: Tana Coman

Designers: Tana Coman, Tom Varisco

Photographers: Frank Rogozienski, Jackson Hill, Michael Terranova

Client: *Tulanian*/alumni magazine

Problem: Client wanted a more distinctive look.

When Tom Varisco was contacted about redesigning Tulane University's alumni magazine, *Tulanian*, the university's officials said they wanted a change from the magazine's traditional look. Knowing that an alumni magazine couldn't be too edgy, Varisco nevertheless felt that a total departure from their previous look was in order. "The one obvious way to make it distinctive was to go with something completely different from what it had been before," he relates. After checking with his client, Varisco got the go-ahead to come up with a totally different look for *Tulanian*'s cover.

Varisco started by replacing the former cover's full-bleed treatment with a mostly white cover. "There's an opportunity to do something a little more surprising with a white cover—a playfulness that you don't have with a bleed photo," he states. Varisco's new cover layout offers the flexibility of using bordered or silhouetted photos. Black rules at the bottom of the cover suggest a frame, but don't restrict the cover's image, and serve as a means of calling attention to feature lines.

The *Tulanian* logo, created from a modified version of Raleigh, replaces the traditional-looking logo, set in Times Roman. It's prominently featured in black against the cover's white background. Varisco carried the lean, elegant look of the logo into headings for the magazine's columns and table of contents.

Since the initial redesign, in Varisco's role as *Tulanian*'s design consultant he has worked with art director Tana Coman on covers and feature layouts and been art director for photography. Although *Tulanian* has a staff photographer who is often used, local photographers frequently get involved for the opportunity to flex creative muscle while bringing the clever cover concepts to life.

Tulanian's former covers prominently featured full-bleed concept photos. Although the magazine had a professional look, its editors felt a change was in order.

The redesigned Tulanian sports a look that's fresh and contemporary, without alienating older readers.

The white area surrounding Tulanian's cover visuals can be used as a border or as a background for silhouetted images. It also afforded Varisco the opportunity to create the unexpected.

The design of Tulanian's table of contents echoes the look established with its cover.

CONTENTS

8 Do You Know What It Means to Myth New Orleans? *by Mark Miester (A&S '90)*
Reality meets mythology in the "Big Easy Crescent City That Care Forgot."

16 Legacy of Learning *by Roxane Pickens (N '95)*
As Tulane College (formerly Arts & Sciences) celebrates its sesquicentennial, alums look back at their college experience.

24 Gilliland's Isle *by Nick Marinello*
Tulane's new provost, Martha Gilliland, hits the beach running as she helps navigate Tulane toward the new century.

3 To the Editor
4 Research Notebook
6 Bookmarks
30 In the News
35 Essays
38 Athletics
40 New Orleans
41 Alumline

TULANIAN

Working Woman Gets Reorganized for a Faster Read

Firm: Roger Black Inc.

Art director: Mary Jane Fahey

Designer: Mary Jane Fahey

Client: *Working Woman*/professional women's magazine

Problem: Magazine needed new look and improved readability.

The hiring of a new editor at *Working Woman* heralded a new beginning and a new look for the publication—a monthly magazine that helps professional women with their careers and money management. When editor Bernadette Grey and her associates approached Roger Black Inc. about redesigning the magazine, they knew they wanted a new look, but were unsure of what that should be. "There was talk of being able to achieve an urgent read and be more contemporary," recalls senior designer Mary Jane Fahey. However, Black and Fahey felt a content redesign was at the heart of achieving *Working Woman*'s "fast read" objective as well as the look the editors wanted.

"My only directive on this magazine was to make it so a person like myself would pick it up," says Fahey, who describes herself as a "really busy, urban person who's got a modern sensibility and is not afraid of power." Fahey attacked the organization of the magazine's editorial matter and came up with a way to reformat it so the most interesting and essential information is brought into prominence. "We established a financial section for each department," says Fahey. "It existed before, but it was all thrown into the 'Workshop' department that appeared in the back of the magazine. Now it's highlighted up front so it can address what the audience is concerned with—business."

Typefaces were changed for a more contemporary look. Modern No. 20 was chosen as the serif typeface used for columns, departments and as an accent face on features; Univers and Glypha were chosen as sans serif display fonts.

Fahey and the Roger Black Inc. design team also came up with a new idea for magazine visuals. "I wanted it to have more photography," says Fahey, referring to the former design's heavy use of editorial illustration. "I didn't want anything to look like filler. I wanted it to look informative." Fahey and her team researched local photographers accustomed to shooting concept-based photography and came up with a resource list that was given to *Working Woman*'s art director and in-house design staff.

For the cover photography, which typically depicts a successful career woman profiled within, Fahey recommended a shift to a more casual approach. "The individuals shouldn't be handled as corporate photography," she says of the magazine's former approach of positioning its cover subjects in stiff, formal poses and dressing them in business suits. "Most of us wear more casual attire to work," Fahey explains. "The idea was to more accurately reflect our lives."

Another essential element in the magazine's cover redesign was its gutsy logo. "It was meant to convey modern woman," says Fahey, "It's powerful—there's nothing 'pretty' about it."

Working Woman's new cover design depicts its cover subject in casual, contemporary attire and sports a stronger logo.

Before

After

Although "Fast Forward" was intended to be a fast read of newsworthy information, the old design made it seem less newsy and longer than it should have been. The new design for "Fast Forward" exemplifies Working Woman's new look with its use of charts and other information that can be read at a glance.

Before

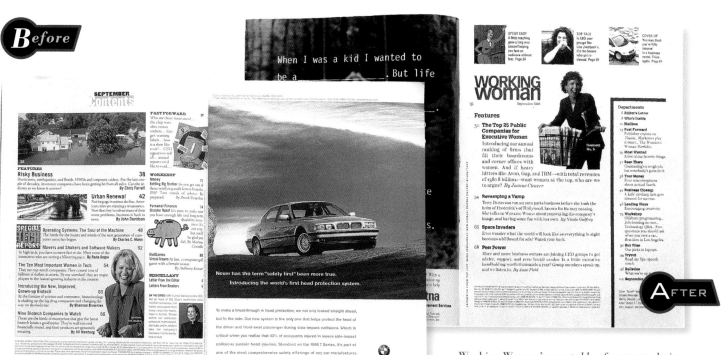

After

Working Woman's new table of contents design makes features and departments easier to find and reflects the magazine's new organization.

BRANDING
AND
IDENTITY

FIRSTAR

ISU Bengals Get a Unique New Look

Firm: Rickabaugh Graphics

Art director: Eric Rickabaugh

Designers: Rod Smith, Dean DeShetler, Eric Rickabaugh, Mark Krumel

Client: Idaho State University

Problem: Client needed an athletic identity it could call its own.

When Eric Rickabaugh of Rickabaugh Graphics met with Idaho State University officials, he discovered that ISU's existing athletic identity was similar to that of some other schools. "Their logo was a monogram design which borrowed heavily from the University of Miami's logo," says Rickabaugh, noting that ISU's depiction of its tiger mascot "borrowed from a logo LSU uses. They realized it was time to create something unique and their own."

Idaho State wanted a versatile identity that made use of a logotype, monogram and a Bengal tiger. They also wanted a youth mark incorporating a tiger that would coordinate with the other identity components.

Since a number of school and pro teams use a tiger as part of their identity, Rickabaugh Graphics first researched existing logos to be sure they wouldn't design an identity similar to one that already existed. "We also did a lot of interviews with the client as well as some focus group studies to help us learn what their view is of their team and their school," Rickabaugh relates. "That helps to make it more unique."

His firm came up with designs for two versions of the tiger mark, a monogram design bearing a paw print and scratch marks and a logotype incorporating the paw print and scratch marks used on the monogram. Rickabaugh Graphics also designed two versions of the youth mark as well as a separate paw print. "We wanted to provide a lot of alternatives so there are lots of choices for the vendors," says Rickabaugh regarding the use of the various identity components on clothing, souvenirs and other merchandise.

Idaho State's former identity—a monogram and a tiger wearing a monogrammed hat—wasn't unique to the school.

BENGALS

IDAHO STATE™

Idaho State's new identity consists of several coordinated components that can be used in a variety of ways on a broad range of merchandise.

The youth identity Rickabaugh Graphics designed has also become a favorite of ISU students. The head and full-body versions echo the two versions of ISU's tiger mark.

Rickabaugh Graphics also came up with a design for ISU's football uniforms.

Brand Redesign Includes Company Makeover

Firm: The Leonhardt Group

Art director: Ted Leonhardt

Designers: Steve Watson, Ray Ueno

Client: Fisher Companies Inc./multi-million-dollar corporation

Problem: The corporation needed to unify its holdings by identifying them as subsidiaries of the parent company.

When the Leonhardt Group developed a new corporate identity for Fisher Companies Inc., the design firm got involved in much more than designing a logo and accompanying business materials—the scope of the identity redesign for the ninety-year-old company required extensive research and the development of a new umbrella brand architecture for Fisher.

The Leonhardt Group was commissioned in 1998 to help unify Fisher's three independent businesses—Fisher Broadcasting, Fisher Mills and Fisher Properties—in the minds of consumers. "Our assignment was to analyze the best way to visually represent that," says principal Ted Leonhardt.

After a yearlong brand audit of Fisher's three divisions, the Leonhardt Group discovered that in spite of Fisher's long history of community involvement in the Seattle area, very few members of the public were aware of Fisher as the parent company of the three divisions or knew that any of the businesses were even connected. As a result, the Leonhardt Group recommended that Fisher go with a very aggressive, single umbrella brand architecture. "With their blessing, we developed the Fisher logo and applied it," says Leonhardt.

The new Fisher logo is based on a flag. "There's a sense of community pride and purpose in the company," says Leonhardt. "There's a lot of employee pride and a sense of empowerment. It's almost like being a country. Because of that, our creative team felt that a flag best represents that idea." The decision to use the letter *F* within the flag came about as a result of researching the Fisher name. "There are many companies named Fisher," says Leonhardt. "It was decided that the best way to distinguish this Fisher from other Fishers was by creating a separate logo." As a result, the Leonhardt Group created a combination of a mark and a logotype.

The Leonhardt Group produced a digital presentation, a video and a style manual showing how the Fisher mark and logotype can be configured to satisfy the corporation's need to display the Fisher name in a variety of venues. Applications include signage and flags at the corporate headquarters as well as company vehicles and employee uniforms.

In many cases the Fisher logo appears in tandem with a division's existing identity. "The broadcast properties use their own identities, but the stations are endorsed by the new Fisher identity and the Fisher organization," says Leonhardt. As Fisher continues to implement additional applications of its new logo, the Leonhardt Group will continue to be involved. "The way we play out our strategy requires that the new identity be driven as far down into the organization as we can," says Leonhardt. "By creating a brand architecture that signifies the unity of the Fisher business, we've raised consumer brand awareness to a new level."

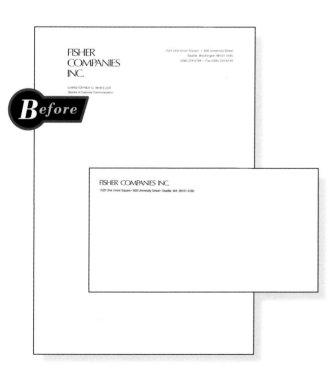

TRANSPARENT UMBRELLA BRAND ARCHITECTURE

Fisher Companies Inc. had no distinctive corporate identity. The variety of identities that had developed over the company's ninety-year history reflected its expansion in response to growth opportunities. Fisher needed a branding strategy that would unify its subsidiaries as Fisher-owned properties.

The headquarters for Fisher-owned mills and broadcasting divisions will display the Fisher mark and name in sizes and configurations that suit each location's needs. The Fisher flag logo is also flown on a real flag at Fisher subsidiaries and at the entrance of Fisher's corporate headquarters.

AGGRESSIVE UMBRELLA BRAND ARCHITECTURE

The new Fisher identity is part of an aggressive branding architecture that will feature the Fisher logo alone on Fisher-owned products and in combination with the entity logos for Fisher-owned entities. The strategy identifies Fisher as the parent company behind all of Fisher's subsidiaries.

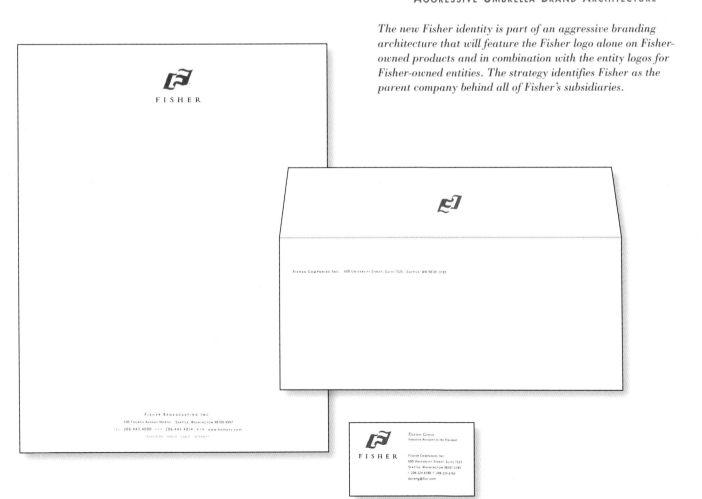

Body-Conscious Image Suits Exercise Gym

Firm: Evenson Design Group

Art director: Stan Evenson

Designer: Ken Loh

Client: Private Exercise/private gym

Problem: Company's existing logo didn't convey personal fitness.

*Private Exercise's former logo didn't communicate
fitness or exercise.*

Private Exercise's new identity first began when its owners contacted Evenson wanting a more contemporary look. "It's a small gym in Los Angeles," says Evenson Design Group's Stan Evenson. "They cater to personal trainers' clients." The gym's former logo wasn't poorly designed, but it failed to express exercise or physical well-being.

Evenson and his design team came up with several design ideas depicting exercise equipment, but the concept to which Private Exercise's owners responded most positively features abstract line renderings of a man and woman. Evenson thinks the concept was well received because it captured the human element. "They pride themselves on a warm and friendly atmosphere," he says of the gym.

For Private Exercise's letterhead and business materials, the mark is flanked at top and right with *Private Exercise* set in an extended version of Copperplate. After Evenson Design presented a variety of color combinations, including two-color and four-color applications, Private Exercise chose a sophisticated palette of teal, copper and black.

In addition to stationery and business cards, the Private Exercise logo appears on signage, product labels and a T-shirt. In exchange for his firm's design time on these projects and the logo design, Evenson received a lifetime membership to the gym. "We're also working on their Web site, and we developed an entire vitamin/supplement product line, so I can send my staff there, too," says Evenson.

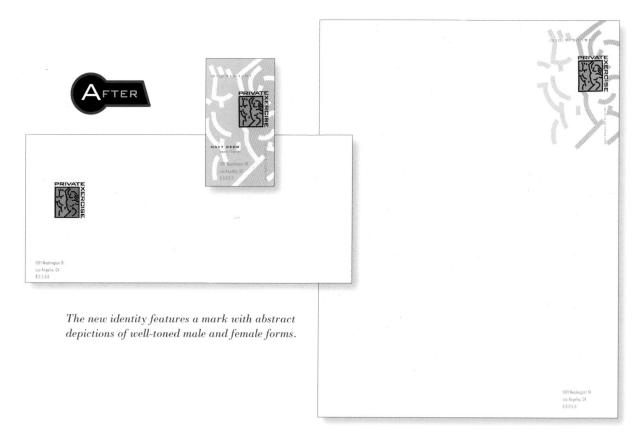

*The new identity features a mark with abstract
depictions of well-toned male and female forms.*

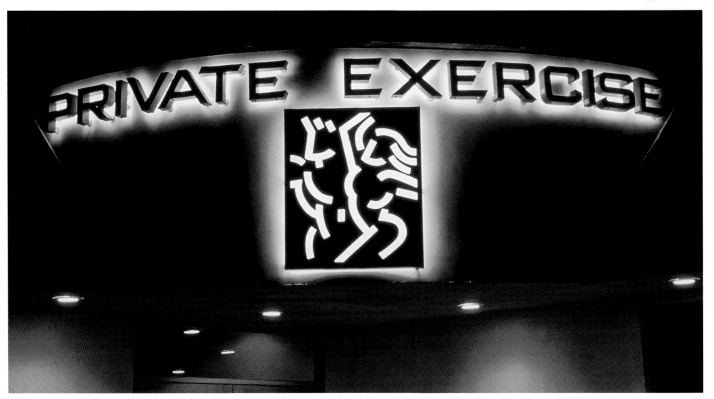

The new logo is featured prominently on signage at the gym's entrance.

The classic Private Exercise mark was broken down into individual male and female components to identify the gym's men's and ladies' rooms.

For Private Exercise product labels, Evenson Design dimensionalized the logo with Stratavision, a 3-D modeling program.

Regional Health Care Provider Needed to Focus Its Brand Identity

Firm: Corbin Design

Art director/project manager: Mark VanderKlipp

Designers: Stacey Griffith, Karin Vajda

Client: Munson Healthcare/health care system

Problem: Client wanted to establish a brand that could be carried through all of its subsidiaries.

Munson Healthcare is an expanding health care system that owns or has an operating arrangement with various health care facilities in the northwest portion of Michigan's lower peninsula. As the umbrella organization over many health care locations, Munson called in Corbin Design to solidify its image by designing an identity system that would work for each of its partners. In addition to Corbin Design personnel, the project team consisted of individuals from within the Munson Healthcare organization as well as freelance designers who do a variety of ongoing work for Munson.

"The primary problem was that each entity had its own mark," says the project's art director, Mark VanderKlipp, of the logos of the various subsidiaries that fell under Munson Healthcare's domain. The project team determined that the Munson *M*, a diamond-shaped icon that was already being used extensively within the system, had considerable brand equity. "Over 85 percent of the people interviewed knew exactly what the icon stood for, but were mistaken in that they thought it represented only the Munson Medical Center in Traverse City," says VanderKlipp.

Because of its high recognition value, the project team decided to retain the *M* icon as a mark for all of Munson's subsidiaries. The logo is placed in the same relationship to the typography for each identity application. Rather than using Optima, commonly used in health care identities, Corbin recommended Frutiger Condensed. For each corporate entity that doesn't carry the Munson Healthcare name in its title, a smaller byline appears to identify it with the larger organization.

A three-tiered color palette was developed for the new identity, as well. Research showed that the corporate colors, a blue and warm gray, were closely associated with the Munson M icon. "We chose to retain the Munson blue (Pantone PMS 302) and darken the Munson gray (PMS 404) slightly," says VanderKlipp. "We also developed a palette of secondary colors that can be used in a variety of applications."

A comprehensive graphic standards program was developed for all potential applications of the new Munson Healthcare identities. Working with Munson staff, the Corbin team developed guidelines for creation of new identities, corporate stationery, forms, print and electronic communications, vehicles and interior and exterior signage applications. "An identity system is only as effective as the people who implement it," says VanderKlipp. "Munson Healthcare's new corporate guidelines are now in use systemwide because so many of the people who work with them were involved early on."

Munson's affiliates and subsidiaries had some graphic elements in common, but their graphic identities lacked a common look that would immediately identify them as part of the same family of health care facilities.

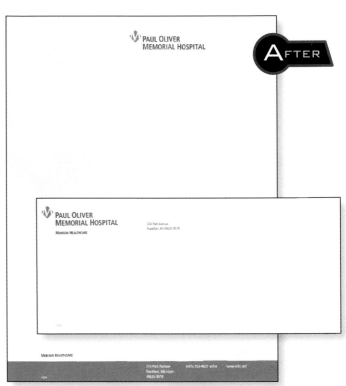

The redesign of Munson's identity included stationery for all of its facilities.

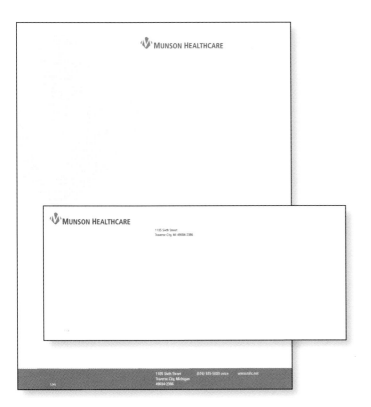

The covers of Munson's new brochures display an image and graphic treatment consistent with its ads. The brochures are printed in colors from Munson's new corporate palette.

MUNSON BEHAVIORAL HEALTH
A **MUNSON** MEDICAL CENTER SERVICE

MUNSON HEALTHCARE
Your Health...Our Mission

PAUL OLIVER MEMORIAL HOSPITAL
MUNSON HEALTHCARE

LEELANAU MEMORIAL HEALTH CENTER
MUNSON HEALTHCARE

With Munson's new identity system, it was important for each facility to maintain its existing name for its recognition value. Adding the Munson M and creating a standard treatment for type helped to unify the look of all of Munson's facilities.

Software Manufacturer Consolidates Its Image

Firm: Hornall Anderson Design Works, Inc.

Art director: Jack Anderson

Designers: Jack Anderson, Debra McCloskey, Heidi Favour, Larry Anderson, Jana Wilson Esser, Nicole Bloss

Client: Novell/network software provider

Problem: Former packaging didn't project a consistent image.

Novell realized it had an inconsistent identity when the provider of network software contacted Hornall Anderson Design Works, Inc. about a brand and packaging redesign. "They had several identities going on at the same time," says Hornall Anderson designer Larry Anderson of the variety of graphic treatments applied to Novell's product packaging. "Because a lot of people didn't even know who Novell was, we decided to put their name front and center," says Anderson.

The strong and simple typographic statement that is the new Novell logotype is displayed prominently on the company's software packaging. The boxes also feature two-color images to represent Novell's individual product groups. "It embodies what the software group symbolizes," explains Anderson. Because the packaging serves more of a utilitarian purpose, it still needs to retain specific design criteria consistent with the new Novell branding.

From there, Hornall Anderson Design Works, Inc. developed a packaging system that uses a consistent box and plays up the company's signature colors of red and white. In addition to combinations of red, white and black, kraft paper was also added to the color palette. "It helped to keep costs down and projects a user-friendly look," Anderson relates. "Technology can be so hard edged," says Anderson. "The kraft paper softened their image a bit."

Novell's former packaging used a variety of graphic treatments including a triangular "shark's teeth" logo and an inconsistent typographic treatment of the Novell name. Its corporate collateral presented an inconsistent image.

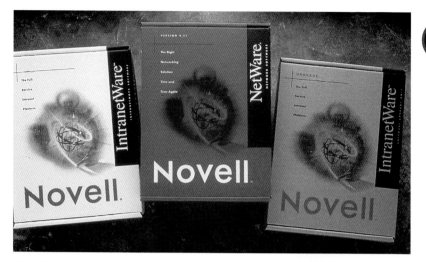

Novell's new packaging sports a new look and a new logo. Both were created to improve the brand's position with a stronger treatment of the Novell name and a more consistent graphic image.

The redesign of Novell's software packaging represents a major rebranding effort that involved Hornall Anderson Design Works, Inc. in the design of new business and promotional materials for Novell.

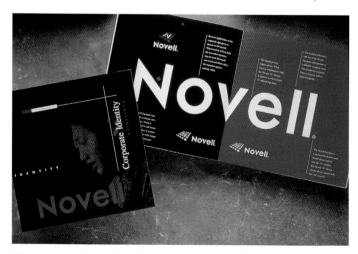

The company's new branding standards were defined in a graphic standards manual which was given to Novell's communications personnel.

New Logo Puts a Happy Face on Children's Shoe Store Chain

Firm: Selbert Perkins Design

Art directors: Robin Perkins, Clifford Selbert

Designers: Julia Daggett, John Lutz, Michele Phelan, Kamren Colson, Kim Reese

Architects: Elkus Manfred

Client: Stride Rite/children's shoe manufacturer and retailer

Problem: Identity needed to be more clearly directed at children.

Stride Rite is well known for making high-quality children's shoes. In spite of eighty years in the business and a reputation as experts in children's foot development, Stride Rite was losing market share when its children's group contacted Boston-based Selbert Perkins Design about an identity and packaging redesign. The designers at Selbert Perkins felt part of Stride Rite's problem was the abstractness of its existing logo. "It was a little difficult for people to comprehend," says principal Robin Perkins of the logo's rough depiction of a leaping child, designed over fifteen years ago.

"One of our challenges was to create a very simple, clear visual identity that talks about what the company is—it's all about children," she relates. Through research involving Grey Advertising, Selbert Perkins discovered that children and the joy of being a child were important to reaffirming the Stride Rite brand as specialists in children's shoes. It was also important to develop a lighthearted approach to which kids, as well as adults, could relate. "We put ourselves in a kid's shoes—no pun intended," laughs Perkins.

The logo idea Selbert Perkins conceived focuses on a childlike drawing of two children. To address a multicultural audience, the logo is twofold, presented as a positive image of one child's face against a light background and another similar image against a dark background. "We felt it was a good overall mark that was easy to understand and a very global approach," says Perkins. The logo's sense of childlike whimsy is reinforced by flipping the letter *i*. "It's something that a kid would do," explains Perkins. To complete the new identity's childlike sensibility, a palette of primary colors was used for the logo, packaging and in-store displays and signage.

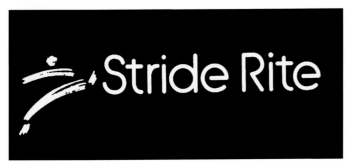

Although it depicts a leaping child, the abstractness of Stride Rite's previous logo failed to communicate a childlike image.

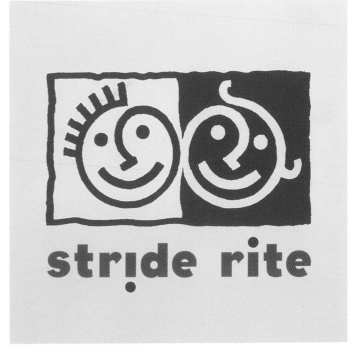

"It's all about children," says Robin Perkins of the simple, straight-forward visual identity Selbert Perkins designed for Stride Rite.

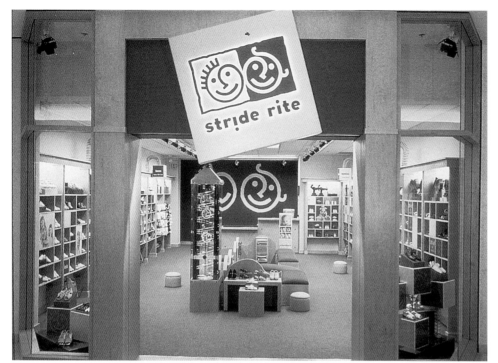

Selbert Perkins worked with Stride Rite to carry the new logo concept into packaging and in-store display and signage.

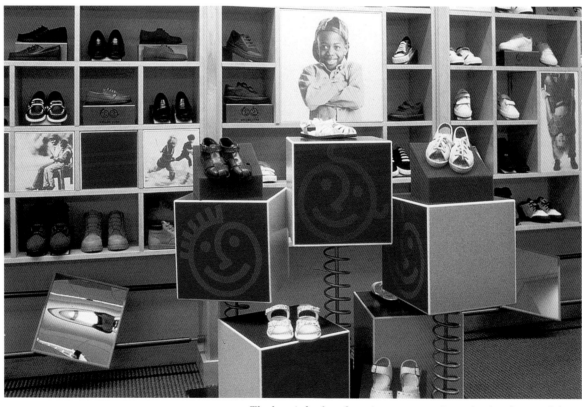

The logo is broken down into square units and printed on modular display cubes that can be arranged in a variety of configurations. To complement the display cubes, Selbert Perkins conceived the in-store wall display's square "cubbies." "The shelving idea was related to the cubbyholes children have at school for storage," says Perkins.

Bank Stars Merge to Form New Identity

Firm: Libby Perszyk Kathman

Art director: Tim Smith

Designer: David Frank

Client: Firstar Corporation/bank

Problem: The merging of two bank corporations brought about the need for a new identity.

When Star Banc Corporation of Cincinnati and Firstar Corporation of Milwaukee merged, the combined organization, known as Firstar, needed a new identity. "Our goal was to leverage whatever combined equities that we could, while still reinforcing the positioning for the combined organization," says John Recker of Libby Perszyk Kathman (LPK), the design firm behind Firstar's new identity.

Recker explains that the new logo needed to express the personality of both banks' existing identities. "The type treatment is very similar to the original Firstar typography. We did some minor manipulations," says Recker, referring to refinements LPK's designers made to the new Firstar logotype. The designers combined the logotype with the star symbol that played an integral role in both banks' former identities. "We wanted to use the star, but do something that was completely ownable," says Recker. The solution was to add an energizing arc. The oblique treatment of the star also adds energy and a sense of optimism.

The LPK design team added an element from Star Banc Corporation's original logo by placing its tag line, "Bank Without Boundaries," beneath the new logo. "That's really what we were trying to communicate through the identity—accessibility and progressiveness," says Recker.

The LPK design team chose to modify Firstar's original green color palette: they chose Pantone PMS 3415, a brighter, fresher green for the logo's star symbol. "The new green has integrity and credibility, but it's a little more friendly," Recker explains.

When Star Banc Corporation and Firstar Corporation merged, the integrated company needed a new identity that would capture elements of both banks' former identities.

Bank Without Boundaries

Firstar's new logo brings together graphic elements from both banks' former identities.

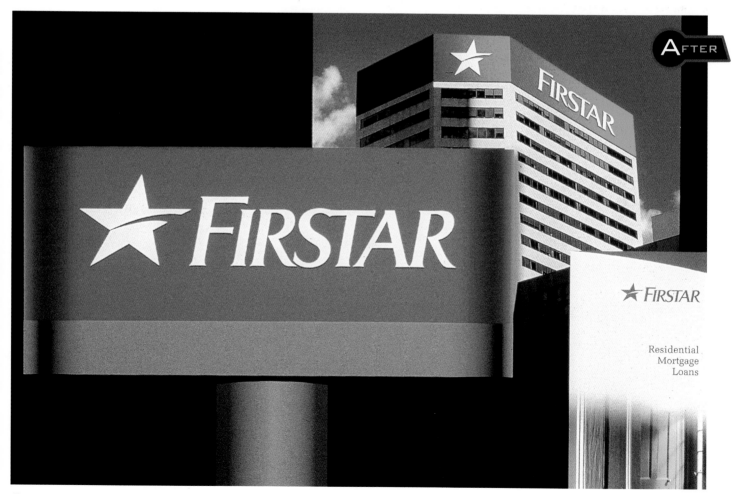

Firstar's new identity appears on signage, ATM machines and billboards.

New England Patriots Update Their Image

Firm: Evenson Design Group

Art director: Stan Evenson

Designer: Ken Loh

Client: NFL Properties/football franchise managers

Problem: Football team needed a more contemporary image.

The New England Patriots' former logo depicted a circa-1776 football player in a three-point stance.

When the New England Patriots approached NFL Properties wanting a new logo, the football team's management thought its existing logo looked dated. "They felt they had one of the oldest logos in the NFL," says Stan Evenson of Evenson Design Group, the design firm behind the Patriots' current logo design.

As one of three design firms involved in the redesign, Evenson and his firm were given a directive to come up with a more contemporary logo design with a patriotic theme. "We knew we had to work with red, white and blue and patriotic motifs, but how do you take the obvious and depict it in a unique way?" Evenson says.

His firm's answer was to modernize the patriot in the existing logo by portraying him as an abstracted profile in a hat bearing stars and stripes. This solution, one of several the firm submitted, was the one the Patriots management liked the best. From there, refinements were made over a three-month period. "Our biggest struggle was simplifying the face and dealing with the scale of the hat," relates Evenson. The result is a striking motif that Evenson says Bostonians fondly refer to as the "flying Elvis logo."

The logo was such a marked departure from the literal depiction of the patriot previously used, the Patriots managers felt it needed to be counterbalanced with a conservative uniform design. As a result, Evenson Design came up with an approach that employs red, white and blue and confines the logo to the uniform sleeve and helmet.

Although the new logo design departs from more conventional approaches, its look has caught on. "There have been a lot of face-lifts and redesigns in the NFL since it was introduced," says Evenson.

The new design streamlines the patriot into a racier and more contemporary logo.

In addition to helmet and uniform applications, the New England Patriots' logo appears on the center of their playing field.

An alternative approach Evenson Design offered displayed a frontal view of the patriot.

OTHER

Shakespeare Goes Contemporary

Firm: Acme Design Company

Art director: John Baxter

Designer: John Baxter

Client: Wichita-Sedgwick County Arts & Humanities Council

Problem: Client needed poster to appeal to a broader, more youthful audience.

Making Shakespeare a marketable commodity is easy if you know how to present him within the context of today's media. John Baxter, of Wichita, Kansas-based Acme Design Company, discovered this when he was faced with the challenge of creating a poster to promote the celebration of William Shakespeare's birthday. Says Baxter, "It's an annual party that was initiated by a man who works for the local paper." The party started in his office about fifteen years ago and has grown substantially since then. In fact, in recent years the party has drawn 1,000 to 2,000 people.

In 1996 the party's primary sponsor, the Wichita-Sedgwick County Arts & Humanities Council, decided to put more effort into its promotion. Baxter was recruited by his former high school English teacher, who serves on the council's board, to design a poster worthy of the party's elevated status.

Baxter's solution was to reposition Shakespeare in a contemporary publicity venue. "I thought about Shakespeare casting characters in stories about the human condition," says Baxter. "I thought that turnabout was fair play, so he became Jerry Garcia." Baxter's first poster replicates the psychedelic look of posters used to promote Grateful Dead concerts in the 1960s and 1970s. He started by colorizing a black-and-white engraving of Shakespeare, supplied as a transparency by Archive Photos. To preserve as much detail as possible when the 4" x 5" (10.2cm x 12.7cm) image was enlarged to poster scale, Baxter had a service bureau make a high-resolution line art scan of the image. The type is set in Desdemona, a typeface originally designed in the 1970s, which Baxter altered and added a gradient to on the computer.

Previous posters promoting an annual birthday party for Shakespeare weren't as eye-catching or as elaborate as recent posters.

For an authentic Rolling Stone *look, Baxter set cover headlines in Parkinson, a typeface designed by Jim Parkinson and used frequently by the magazine in the 1970s.*

The following year yielded a characterization of Shakespeare as "Bard and Bard" in a parody of a Ringling Brothers, Barnum and Bailey circus poster. In 1998, he became the subject of tabloid gossip ("Shakespeare in Love Triangle") shortly after the Bill Clinton/Monica Lewinsky affair came to light.

"My greatest dream has been to design a cover for *Rolling Stone*," says Baxter, regarding his most recent poster. Although the council liked the *Rolling Stone* concept, Baxter was concerned that the magazine might not grant permission for the use of its name. After contacting *Rolling Stone* senior art director, Gail Anderson, Baxter was surprised and delighted to find out that not only could he do the cover idea, "She also sent me the logo art from the cover," says Baxter. In exchange, Baxter ran a small credit line at the bottom of the poster and forwarded ten copies to Jann Wenner, *Rolling Stone* publisher and cofounder, "because he collects parodies of the cover," Baxter explains.

To re-create the typography of a circus poster, Baxter scanned a Ringling Brothers, Barnum and Bailey poster, traced some of the lettering and interpreted other letterforms in Macromedia FreeHand to spell Bard and Bard *and* Greatest Prose on Earth.

Web Site Gets New Look and Improved Navigation

Firm: Xeno Design

Art director: Chris Garland

Designer: Chris Garland

Programming: Miller Media & Imaging

Client: Bausch & Lomb Surgical, Inc./providers of a complete procedural approach to vision care

Problem: Client needed Web site to make use of state-of-the-art technologies and present an image in step with printed materials.

Chiron Vision, a California-based manufacturer of ophthalmic surgery supplies, established a modest presence on the Web in 1996, but did little to upgrade the site until its new owner, Bausch & Lomb, combined the resources of Chiron Vision and Storsz Instrument Company.

"It was time to trade in and trade up," says Chris Garland of Xeno Design, the design firm behind Bausch & Lomb Surgical's new Web site. The redesign needed to keep surgeons and other medical professionals up-to-date with the latest advancements from the company, offer procedural information to patients and provide an online product catalog coupled with an e-commerce solution.

"The first thing I do when I'm designing a site is a flowchart," says Garland. "From there, the solution begins to design itself." Garland set up a navigational means that allows users to access on the left the main menu and the categories within each section of the site. Familiar product lines are also easily accessible by selecting buttons with product logos on them below the main menu.

Garland and his client both wanted a classic look for the site. "I didn't want someone to say, 'This is out of date; we need to redo it,' anytime in the near future. I wanted to make it clean and solid," he states. Garland was also mindful of the company's approved color palette and new artwork created for print production by another firm. Web page layouts were first created in QuarkXPress for quick handling and ease of refinement, then documents were delivered to Miller Media & Imaging for programming and assembly.

What is now www.blsurgical.com was previously www.chironvision.com.

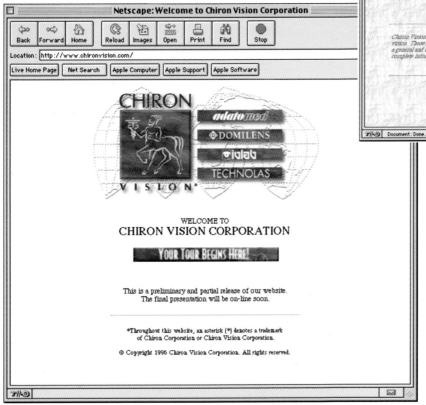

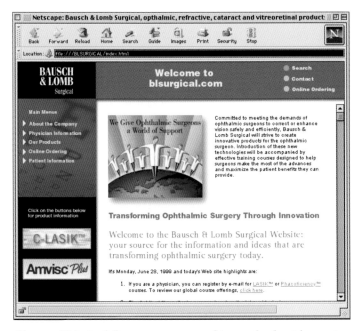

The new Web site follows corporate graphic standards with creative adjustments made for Internet purposes. Continuity is maintained as much as possible between the site and the company's collateral materials.

The site includes password-protected online ordering capabilities where registered users can access a full e-commerce subsection.

When users access other key areas of the site via the home page's main menu, navigation controls on the left switch to a menu of subcategories within that area. Main menu choices are available below.

Web Site Reinforces New Identity

Firm: Corbin Design

Art director/project manager: Mark VanderKlipp

Designers: Stacey Griffith, Christina Schoenow, Rick Stringer, Karin Vajda

Client: Munson Healthcare/health care system

Problem: Client needed its Web site to reflect new brand identity and be more user friendly.

Munson Healthcare, a network of health care facilities in northwest Michigan's lower peninsula, was able to establish a stronger brand presence through the efforts of Corbin Design (see pages 118–119). When Corbin completed the identity makeover, Munson Healthcare recruited the design firm to redesign its Web site.

Corbin's designers felt that it was important to incorporate the look and feel of the Munson identity into the site's design. "At that point, their Web site wasn't an extension of the Munson Healthcare brand," explains Corbin Design's senior vice-president, Mark VanderKlipp.

The design team started with a restructuring of the existing content on the Munson Healthcare site, adding new features identified by Munson's marketing department. Once this was approved, Corbin's design team could move forward with the design of the site.

Munson Healthcare's old Web site didn't reflect the organization's new image.

A button on the home page changes every thirty seconds to allow users to instantly access information on some of Munson Healthcare's most frequently sought services: cosmetic surgery, cancer care and heart services. When one of these three categories is selected, the user is linked with the category's subsite, offering additional options and links.

The new site features photos with a visual treatment that's consistent with Munson's redesigned print collateral. To help users navigate the site, main menu categories at the top of the home page also display subcategories.

An important part of the site's design is the use of visual elements employed in Munson Healthcare's advertising and brochures. Photographs are given a duotone treatment, consistent with Munson's printed materials. Other identity elements were also brought into the site, including Munson's corporate colors, which appear on the site's upper-level category menus. Even the tone of the writing matches across all media so that the Munson Healthcare "voice" comes through clearly.

"We wanted to give people an opportunity to easily access information in a more logical way," says VanderKlipp. The design team established this by making all parts of the site visible and accessible from its home page. In addition to the major category menus at the top of each frame, the designers added navigational elements to the bottom that provide instant links to more utilitarian parts of the site, such as a search engine and site map.

The ability to post current information online, such as news releases and employment, is an important feature of the new site. Corbin worked with a technical resource to develop a Web browser-based form that allows Munson employees to easily update the site.

Mailer Becomes More Attractive and Secure

Firm: Rickabaugh Graphics

Art directors: Mark Krumel, Eric Rickabaugh

Designer: Dave Cap

Client: Huntington Banks

Problem: Client needed a more secure and user-friendly mailer.

Like many financial institutions, Huntington Banks recently initiated online banking. When the bank started this service, it sent its customers a pocket folder within a window envelope that included a user's guide and a letter with the customer's code and account number, as well as a form and several business reply envelopes. The package contained everything that a customer would need, but it prompted security concerns. Contents could jiggle around inside the envelope, possibly allowing account numbers and codes to show through the window. The adhesive-sealed envelope also wasn't tamperproof.

Huntington Banks representatives turned to Rickabaugh Graphics for a design solution that would not only make the package secure, they also wanted a mailer that presented a well-designed, cohesive image.

Led by vice-president Mark Krumel, the Rickabaugh Graphics design team started by coming up with an appropriate size. "We figured most people don't have a lot of space around their computer, so we thought something in a 6" x 9" (15.2cm x 22.9cm) format would work," Krumel relates.

The next step was to determine how to organize the mailer's contents. Huntington representatives wanted the mailer to be as user friendly as possible, with all of its contents easy to find and clearly identified. "They wanted everything to be seen at a glance, so that when you opened it there would be a checklist," says Krumel. With that in mind, designer Dave Cap developed a folder with five pockets. The one on the right-hand side of the folder contains the customer letter, which is folded in half and fitted snuggly inside so that only the customer's name and address show through the window on the opposite side.

The mailer's other contents are inserted into pockets numbered, from 1 to 4, on the left. Pocket number 1 contains the "Getting Started Guide." Authorization forms, a survey and deposit envelopes are clearly labeled as steps 2 to 4. Copy on the right gives users a further explanation of what's involved in steps 1 to 4. To make the mailer tamperproof, Cap specified an enclosure similar to express envelopes, where the user needs to tear off a strip to open the package.

Although they wanted a change from the large pocket folder they had previously used, Huntington Banks representatives liked the look of the user's guide that it contained. Working with the same photograph of a mouse and the Helvetica typeface used on the previous user's guide, Rickabaugh Graphics added the Huntington Banks logo beneath the mouse and coordinated the look and colors of their mailer to reflect the look established within the online banking Web site.

Welcome Kit

Huntington
Take control of your money.™

Huntington Banks's former Web banking package contained a nicely designed brochure and other forms tucked into a pocket folder. The pocket folder and its contents were visually unrelated and presented security problems.

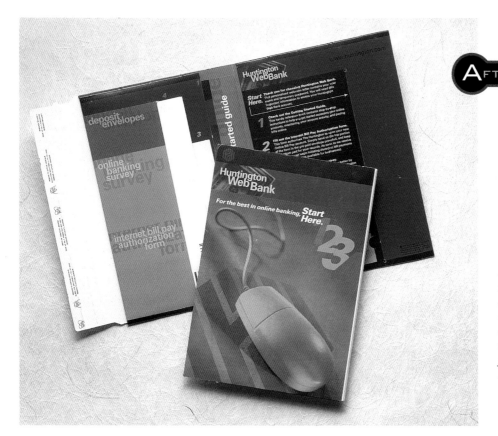

Because their client wanted a look for its new user's guide that was similar to the existing guide, Rickabaugh Graphics used the same photograph of a mouse on the cover. Using Adobe Photoshop, they super-imposed the mouse on a background that features a shadowlike treatment of the Huntington Banks logo.

Rickabaugh Graphics conceived a unified package for Huntington Banks that presents the contents in a way that's cohesive and easy to understand. The mailer's pockets and tamperproof enclosure also ensure that its contents are secure.

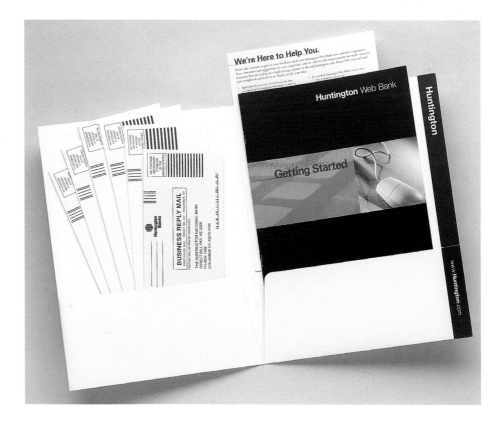

Trivial Pursuit Gets Updated Game Board

Firm: Selbert Perkins Design

Art directors: Clifford Selbert, Lynn Riddle

Designer: Lynn Riddle

Client: Parker Brothers/game manufacturer

Problem: Client wanted a more modern version of a classic game.

The well-known and often played board game Trivial Pursuit was in need of a face-lift when Parker Brothers contacted Selbert Perkins Design. "They felt the entire game needed freshening up, but they couldn't afford to redo all of the packaging and cards. They chose to focus on the board," says firm principal Clifford Selbert of his client's desire to update a game unchanged since its introduction in the mid-1970s.

Selbert Perkins experimented with the idea of replacing the board's illustrations with a combination of illustration and photography, but decided instead to use just photographs. "Photography allowed us to unify the look of the board with images covering the entire century," says Selbert.

Finding nostalgic photos turned out to be more of a challenge than originally anticipated. The designers researched a range of stock sources, but found that purchasing rights for some of the photos was prohibitive. "We had to buy rights in perpetuity," says Selbert. "Some images were too expensive." After Selbert Perkins had located images at a reasonable price, the designers colorized them in Adobe Photoshop with the six colors used for Trivial Pursuit's game pieces.

In addition to executives at Parker Brothers, the redesign process also involved Trivial Pursuit's originators, who had to approve every new idea. Selbert says they were originally concerned about changing the personality of the game. "But they really liked all of our ideas," says Selbert. "The idea was to take a piece of Americana and freshen it up. That can be a challenge," he states. "I think the approach we took worked."

Trivial Pursuit's new board design replaces illustrations with photography. The photographs provide subtle clues and give the new board a nostalgic flavor.

The illustrations used in Trivial Pursuit's original board design had a generic quality that gave them the look of clip art.

Copyright Notices

Index of Design Firms

Index of Clients

Subject Index